WORLD FILM LOCATIONS ATHENS

Edited by Anna Poupou, Afroditi Nikolaidou and Eirini Sifaki

First Published in the UK in 2014 by Intellect Books, The Mill, Parnall Road, Fishponds, Bristol, BS16 3JG, UK

First Published in the USA in 2014 by Intellect Books, The University of Chicago Press, 1427 E. 60th Street, Chicago, IL 60637, USA

Copyright ©2014 Intellect Ltd

Cover photo: *Boy on A Dolphin* (1957) 20Th Century Fox / The Kobal Collection

Copy Editors: Mary Kitroeff and Emma Rhys

World Film Locations Series
ISSN: 2045-9009
eISSN: 2045-9017

World Film Locations Athens
ISBN: 978-1-78320-359-8
ePDF ISBN: 978-1-78320-342-0

Printed and bound by Bell & Bain Limited, Glasgow

WORLD
FILM
LOCATIONS
ATHENS

EDITORS
Anna Poupou, Afroditi Nikolaidou
and Eirini Sifaki

SERIES EDITOR & DESIGN
Gabriel Solomons

CONTRIBUTORS
Lefteris Adamidis, Konstantinos Aivaliotis,
Stavros Alifragkis, Manolis Arkolakis, Erato
Basea, Maria Chalkou, Elena Christopoulou,
Dimitris Eleftheriotis, Leda Galanou, Elias
Fragoulis, Betty Kaklamanidou, Myrto
Kalofolia, Harry Karahalios, Athena
Kartalou, Ursula-Helen Kassaveti, Dimitris
Kerkinos, Yvonne Kosma, Eleftheria Rania
Kosmidou, Angeliki Koukoutsaki-Monnier,
Stelios Kymionis, Manolis Kranakis,
Yorgos Krassakopoulos, Ioulia Mermigka,
Angeliki Milonaki, Despina Mouzaki, Lydia
Papadimitriou, Dimitris Papanikolaou, Efi
Papazachariou, Maria Paradeisi, Thanassis
Patsavos, Despina Pavlaki, Katerina
Polychroniadi, Nick Potamitis, Marios
Psarras, Sylvie Rollet, Yannis Skopeteas,
Nikos Tsagarakis, Vassiliki Tsitsopoulou,
Phaedra Vokali

LOCATION PHOTOGRAPHY
Afroditi Nikolaidou and Anna Poupou
(unless otherwise credited)

LOCATION MAPS
Greg Orrom Swan

PUBLISHED BY
Intellect
The Mill, Parnall Road,
Fishponds, Bristol, BS16 3JG, UK
T: +44 (0) 117 9589910
F: +44 (0) 117 9589911
E: *info@intellectbooks.com*

Bookends: Monastiraki Square
This page: *The Little Carriage* (1957)
Overleaf: Klepsydras Street Plaka

CONTENTS

ACKNOWLEDGEMENTS

This book would not have been possible without the generous assistance of many people. We are particularly grateful to all the contributors for their generosity and to Gabriel Solomons at Intellect who embraced this effort. Special thanks to Mary Kitroeff for her valuable comments and meticulous editing skills. Deserving of special mention are Yorgos Tasioulas, Vassilis Dimitroulias, Christina Sigala (Finos Film), Phaedra Papadopoulou, Stella Kehagia (Seven Films), Maria Drandaki, Liza Linardou, Thanos Anastopoulos, the Greek Film Archive, the Greek Film Centre and the Thessaloniki International Film Festival, who facilitated the process of acquiring the film stills.

THE EDITORS

INTRODUCTION

World Film Locations Athens

THIS BOOK WAS WRITTEN AND EDITED at one of the worst times for the city of Athens, after six years of economic recession and political and social crisis. Paradoxically, this period has also been one of the best for Greek cinema, often categorized under the term 'Greek New Wave', and represented by a new generation of emerging film-makers that blossomed during the crisis. This cinema bears the signature of its times. A kind of urban nostalgia, a constant comparison between the present and the past of the city can be traced in many of the texts that comment on the films and in the photos of the location in their contemporary state, attesting to an aesthetic and political re-evaluation of cinematic urban forms of the past and present.

The filmic geography of this book is not limited to the city's central historical districts and film locations, but also includes the periphery of Athens (popular neighbourhoods, poor suburbs or slums are often represented in the post-war neo-realist films), garden cities and upper-class suburbs (preferred by the auteurs of the 1970s), with an aim to present an exhaustive physiognomy of the city. The story that unfolds through this filmic journey is that of a city full of contrasts, very often caught between modernity and stagnation, reconstruction and demolition, an idyllic touristic location versus a 'dirtopia' as we call it; an eternal ancient topos surrounded by deteriorating city relics.

In this World Film Locations book dedicated to Athens, we tried to present a wide range of Greek and international films shot in Athens, from auteur films to low-budget B-movies, to popular mainstream Greek films, to international blockbusters. Our effort was to give a representative choice and to foreground Greek cinema, from the silent-film period to the present day. As literature in English regarding Greek films is limited, we hope that this book will serve as a guide not only to a discovery of cinematic Athens, but also to a rediscovery of Greek cinema by a wider audience. ✢

Anna Poupou, Afroditi Nikolaidou and Eirini Sifaki, Editors

ATHENS

City of the Imagination

Text by
ANNA
POUPOU
& EIRINI
SIFAKI

CINEMATIC ATHENS as seen in international films is immediately linked to the stereotypical topics of antiquity and tourism, dealing with the rediscovery of its ancient values and heritage, often with a touch of Orientalism and plenty of *couleur locale*. At times, a certain irony is discernible towards the expectations of the visitor, who soon sees his idealized vision of the city of Pericles shattered by Modern Greek reality. On the other hand, cinematic Athens as seen in Greek films is all about change and transformation: about urban reconstruction and demolition, destruction and regeneration, political mutations and crisis.

Few images of Athens survive from the period of early cinema until the 1930s: *I peripeties tou Villar/ Villar's Adventures* (Joseph Hepp, 1924), *O magos tis Athinas/The Wizard of Athens* (Achilleas Madras, 1931) and *Kinoniki sapila/Social Corruption* (Stelios Tatassopoulos, 1933) are precious examples, shot in real locations and documenting the Athenian cityscape during the interwar period. However, it wasn't until the early 1950s, when the city began to recover from the turmoil of World War II and the Greek Civil War, that the Greek film industry started to represent the reconstruction of the city. The bright sun and the fair weather conditions

which permitted shooting with natural light in real locations throughout the year, in addition to the total absence of any infrastructure or studios, transform the picturesque Athenian streets and neighbourhoods into a vast studio, where more than 100 films were shot each year, offering a panorama of all aspects of the Greek capital. The Athenian cityscape sometimes becomes a metaphor for the trauma of the occupation and the civil war, as in Nikos Koundouros's *Magiki polis/Magic City* (1954) and *O drakos/The Ogre of Athens* (1956), Michael Cacoyannis's *Stella* (1955) and Alekos Alexandrakis's *Synikia to oniro/Dream Neighbourhood* (1961). However, in the majority of Greek films, the image of Athens celebrates the post-war economic boom.

For a short period of time, from the late 1950s up until the 1967 *coup d' état*, Athens became a star in big budget international productions. In Jean Negulesco's *Boy on a Dolphin* (1957), Sophia Loren poses in front of the Parthenon as a barefoot girl from a fishing village who found an ancient statue and tries to sell it. In Jules Dassin's *Never on Sunday* (1960), Melina Mercouri strolls on the Acropolis as Ilya, the relentlessly optimistic and headstrong prostitute who represents, to the American Homer Thrace, the contemporary decay of Greece. In Robert Stevens's *In the Cool of the Day* (1963), Jane Fonda climbs the Acropolis Hill in her quest to regain her lost vitality through the discovery of an ancient culture. International divas are shot in front of the national uncontested diva, in sequences full of meaning, connotations and allegories.

Even though big-budget, large-scale international productions abandoned Athens soon after the briefly cosmopolitan 1960s, the city became a privileged location for B-movies, war films, car-chase films and dubious spy adventures. Robert Aldrich can be considered the godfather of this trend with *Angry Hills* (1959), starring Robert Mitchum, followed by Henri Verneuil's *Le Casse/The Burglars* (1971) with Jean Paul Bellmondo and Omar Sharif. In

Anthropophagus (Joe d'Amato, 1980), *Signs and Wonders* (Jonathan Nossiter, 2000), *Dead Europe* (Tony Krawitz, 2012) and various other sensational low-budget adventures, Athens figures as a nest of spies, a dangerous and exotic trap against a backdrop of shadow governments and social unrest, where the past comes alive to haunt the heroes.

In the late 1960s, during the dictatorship (1967–74), a new generation of auteurs emerged, creating a political and independent cinema. In the films of the New Greek Cinema, the Athenian cityscape is depicted through the social problems connected with rapid urbanization and the abandonment of rural areas. The city is represented as the result of real estate speculation in *Prossopo me prossopo/Face to Face* (Robert Manthoulis, 1966); as banishment in *Evdokia* (Alexis Damianos, 1974); and as a place of sexual repression and patriarchal control in *Ioannis o Vieos/John the Violent* (Tonia Marketaki, 1973) and *To proxenio tis Annas/Anna's Matchmaking* (Pantelis Voulgaris, 1974). Finally, Athens becomes a field for the negotiating of recent history and collective memory in the films *Meres tou 36/Days of 36* (1972) and *Taxidi sta Kythira/Voyage to Cythera* (1984) by Theo Angelopoulos; *Kierion* (1968) by Dimos Theos; and *Ta hromata tis iridos/The Colours of Iris* (1974) by Nikos Panayiotopoulos.

For a short period of time, from the late 1950s up until the 1967 *coup d'état*, Athens became a star in big budget international productions.

The 1990s inaugurated a veritable trend of 'city films' which focused on the transformation of the Athenian cityscape: *Apo tin akri tis polis/ From the Edge of the City* (Constantine Giannaris, 1998) traces the urban living conditions of the new demographics that emerged from the flow of immigrants from Eastern Europe. Whether featuring realistic situations, nocturnal *flâneries* during romantic encounters (*Ftina tsigara/Cheap Smokes* [Renos Haralambidis, 2000], *To oniro tou skylou/A Dog's Dream* [Angelos Frantzis, 2005]) or dystopian depictions of society's anxieties, as in *I epithesi tou gigantieou moussaka/The Attack of the Giant Moussaka* (Panos H. Koutras, 1999), their common feature is that their storyline is built around the Athenian city centre, the triangle between Omonia, Syntagma and Monastiraki Squares. These films register a city in transition through a process of gentrification – the remodelling of former industrial zones such as Gazi and Metaxourgio to accommodate new cultural hubs and entertainment venues.

However, the much-touted regeneration of the Greek capital never did take place – either in reality or in fiction. Films made in the 2000s do not represent the anticipated celebration of Athens of the 2004 Olympics, bur rather its decay, as in the film *Tungsten* directed by Giorgos Georgopoulos, filmed in 2004 in the southwest working-class suburbs of Athens but actually released in 2011, depicting a threatening, oppressive, almost deserted city. Similarly, a football match is not an occasion to narrate a national victory but rather a story of disgrace, punishment and forgiveness in *diorthosi/correction* by Thanos Anastopoulos (2007).

After 2008, as Athens enters the spotlight of the international media as a 'City in Trouble', a Greek 'New Wave' emerges drawing attention in the arthouse festival circuit (*Akadimia Platonos/Plato's Academy* [Filippos Tsitos, 2009], *Strella/A Woman's Way* [Panos H. Koutras, 2009], *Hora proelefsis/Homeland* [Syllas Tzoumerkas, 2010], *Macherovgaltis/Knifer* [Yannis Economides, 2010], *Wasted Youth* [Argyris Papadimitropoulos and Jan Vogel, 2011], *To agori troi to fagito tou pouliou/Boy Eating the Bird's Food* [Ektoras Lygizos, 2012], *Luton* [Michalis Konstantatos, 2013], *Wednesday 04.45* [Alexis Alexiou, 2014]). Whether presenting the city centre in decay, with urban riots between the police and protesters, the emergence of racism and neo-Nazism, run-down suburbs and multiethnic neighbourhoods or deserted streets and closed shops, these films record the transformation of Athens in economic and political crisis. Such imagery becomes the new Athens 'landmark', replacing the cinematic hegemony of the Acropolis. Only history will tell if contemporary Greek cinema prefigures indeed a more permanent transformation of symbols in the collective urban memory. ✤

SPOTLIGHT

OPEN-AIR CINEMAS IN POST-WAR ATHENS

Text by
DIMITRIS
ELEFTHERIOTIS

IN THE 1960S, neon lights flickered in the buzzing streets around the centre of Athens. Along Stadiou, Panepistimiou and Akadimias Streets, on Vassilissis Sofias and Patission Avenues, and around Omonia and Syntagma Squares, the presence of global capital was felt through bright, flashing advertisements of products and services that connected the city with the world's international networks of commerce. Particularly striking and full of cosmopolitan seduction were advertisements for airline companies that instantly evoked glamour and freedom in newly discovered globetrotting mobility: Pan Am, TWA, Air France, Alitalia, Lufthansa and of course Olympic Airways, the then luxury company and national treasure owned by Aristotle Onassis, himself a cause célèbre amid the international jet set. Putting the destruction of the post-war period firmly behind it, throughout the 1950s and early 1960s Athens was transformed into an attractive metropolis uniquely combining its classical heritage with modern architecture. Cosmopolitan aspirations were enhanced by new iconic buildings that put the city on the international architectural map:

the new American Embassy designed by Walter Gropius opened in 1961, followed two years later by the Athens Hilton (the 'world's most beautiful hotel' according to Conrad Hilton), designed by the Greek team of Manolis Vourekas, Prokopis Vassiliadis, Antonis Georgiades and Spyros Staikos, while the International Terminal of Athens Airport designed by Eero Saarinen was a work in progress throughout the decade.

At the same time, during the long, hot summer months, in the Athenian neighbourhoods similar bright lights flickered on hundreds of screens in crowded open-air cinemas that stood on public squares, street corners or amongst the newly-built multi-storey apartment blocks that came to dominate the city's built environment towards the end of the decade and the beginning of the next. For most of the 1960s, there were over 400 open-air cinemas in operation in Athens, a city with a population that just nudged over 2 million – a cinema for every 5,000 residents! In the popular Greek films of the period, the lights and sights of the new, Modern Athens became distinctive and recognizable attractions, spectacular moments that froze the narrative and celebrated a newly rediscovered cosmopolitan status.

But viewers would also be treated to films from around the world; in the same way that Athens aspired to find a place amongst the world's great cities, on the screens of the open-air cinemas Greek films were rubbing shoulders with those made in a very broad spectrum of international film industries. While the indigenous sector held a healthy share of the market, American, Italian, French and British films were competing with Indian, Turkish and Japanese productions, creating a most eclectic and peculiarly cosmopolitan viewing 'menu' for the city's cinema-going public. Interruptions were a prominent feature of this mode of viewing: not just the mandatory intervals that initiated social interaction amongst the

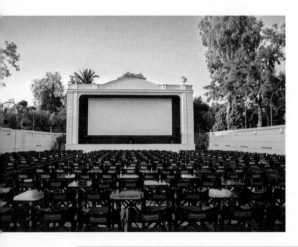

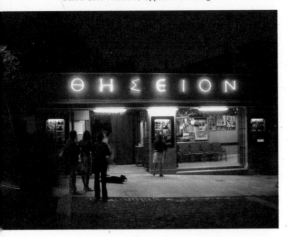

spectators as they wandered around the cinema, but also the intruding noises or lights from neighbouring buildings, the loud comments during the screening or the occasional (usually good-natured) disagreements between members of the audience about the looks, actions or morality of the protagonists.

As Athens walked the tightrope of development and modernization, a precarious balance was struck between the old and the new, between the city centre and the neighbourhoods, with cinemas – open in all senses of the word (to other cultural, geographical, historical and cinematic contexts) – blending the exhibition spaces with the local communities. The integration of the open-air cinema with its context made it a vital part of urban living and a space where friends and neighbours met and interacted, sharing cosmopolitan dreams stirred by the European economic miracle.

However, as development, reconstruction and urbanization intensified in the 1970s, unchecked by planning laws and regulations, the fabric of the city changed, the increasing density turning the earlier celebration of the busy streets into a continuous grumbling about the overcrowded urban environment, its citizens choking under the thick cloud of pollution that blocked out the Athenian sky. Cinemas began to close down, reflecting the film industry's

For most of the 1960s, there were over 400 open-air cinemas in operation in Athens, a city with a population that just nudged over 2 million – a cinema for every 5,000 residents!

own crisis: the 420 open-air cinemas of 1965 were reduced to 310 in 1975 and to less than a hundred by the end of the millennium. It was in the 1970s that the term 'oasis' was first coined to describe open-air cinemas, emphasizing the new function of the venue as a place where you went for a breath of fresh air, to escape from the noise, heat and claustrophobia of the apartment block and signalling the radical decline of the urban configuration that enabled the integration of open-air cinemas with their local communities.

New lights began to flicker in the neighbourhoods, this time from television sets placed on balconies lined with luscious vegetation as Athenians desperately strived to create little private 'oases'. Gradually, as the nuclear family replaced the extended one and as community interaction in the neighbourhoods diminished, scores of open-air cinemas closed down, with the few that remained becoming exceptional spaces, recognized for their historical significance rather than for their direct cultural relevance.

Since the 1990s, a new cosmopolitanism has taken over the city, with hundreds of thousands of immigrants coming into an urban and social space that has proved very reluctant to accept them. Unlike the fascinating cosmopolitan attractions of the 1960s, the recent flows of global displacement are largely viewed as threatening, contaminating the city's ancient heritage, now reclaimed not only by neo-fascists, but also by a considerable section of nostalgic and xenophobic Athenians. Open-air cinemas have by now become truly exceptional, contemporary monuments bearing testimony to a long-vanquished glorious past. Widely reported in the Greek electronic media was CNN's branding of Cine Thisio as the 'world's most beautiful cinema' on the grounds of its unique combination of spectacular views of the Acropolis with the viewing of films, the latter almost a minor distraction that cannot possibly compete in terms of spectacle. Other cinemas, such as the historic Cine Aegli, aspire to establish exclusiveness through segregated seating arrangements that offer a 'private veranda', where a small group can enjoy a four-course meal. Articulating a desire to construct a 'gated' viewing experience informed by exceptionalism and exclusiveness, this appropriation of the venue stands in startling opposition to its 1960s version. But perhaps that should not be so surprising, given that the Athens of the 1960s bears little resemblance to that of today. ✢

ATHENS

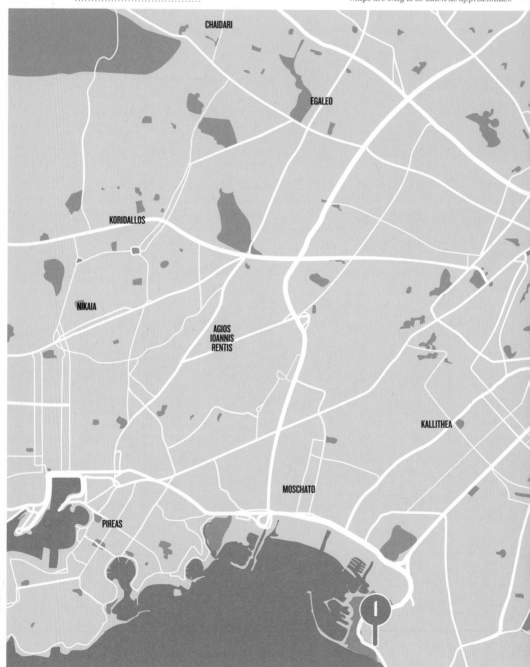

CHAIDARI

EGALEO

KORIDALLOS

NIKAIA

AGIOS
IOANNIS
RENTIS

KALLITHEA

MOSCHATO

PIREAS

ATHENS LOCATIONS
SCENES 1-8

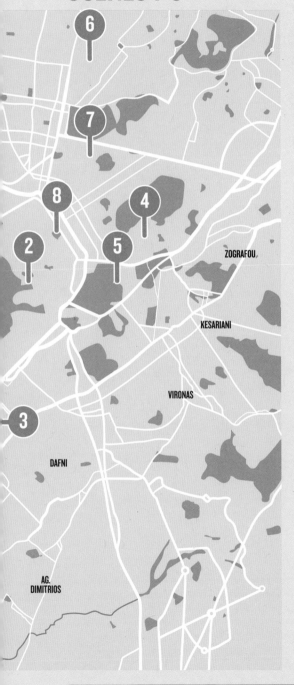

VILLAR'S ADVENTURES/
I PERIPETIES TOU VILLAR (1924)

LOCATION 25 Poseidonos Avenue, Trocadero, Faliro

THE DIRECTOR OF *Villar's Adventures,* the Hungarian Joseph Hepp, arrived in Athens in the 1910s as a Pathé cinematographer, worked as one of the first projectionists in downtown cinemas and was considered one of the pioneers of early Greek cinema. Filmed in 1924, *Villar's Adventures* is a late example of a slapstick chase comedy in which the main actor, Nikos Sfakianakis, tries to embody the Greek version of Charlie Chaplin. The film could be used as a tourist guide: Villar visits the Temple of Olympian Zeus, Philopappos Hill, the Zappeion, Herod Atticus theatre and other monuments. In fact, the succession of the city's locations is used as a narrative structure for the viewer, giving a linear order to the chaos of the primitive narration of this film. In this scene, Villar visits a music club on the Faliro coast. On his way back to the city centre he takes the tram, jumps into a taxi, then onto a motorcycle and finally ends up running towards Syntagma Square. Hepp attempts to show Athenian modernity of the 1920s through the motifs of speed and mobility, showing fashionable clubs and women in bob haircuts dancing to jazz rhythms. However, the empty streets of the upper-class central districts with few pedestrians, little traffic and limited public transport are more evocative of a sleepy Mediterranean town of the nineteenth century. It was precisely during this period that the Athenian conglomeration was redesigned, as the arrival of refugees after the Minor Asia War doubled the city's population and led to the emergence of slums and new working-class districts: Hepp's Athens avoids these mutations and creates an elusive cinematic city enclosed in a sterilized monumentality, dreaming of an imaginary modernity. **➻ Anna Poupou**

Directed by Joseph Hepp
Scene description: Villar visits a club with a jazz orchestra along the Faliron coast
Timecode for scene: 0:05:13 – 0:11:22

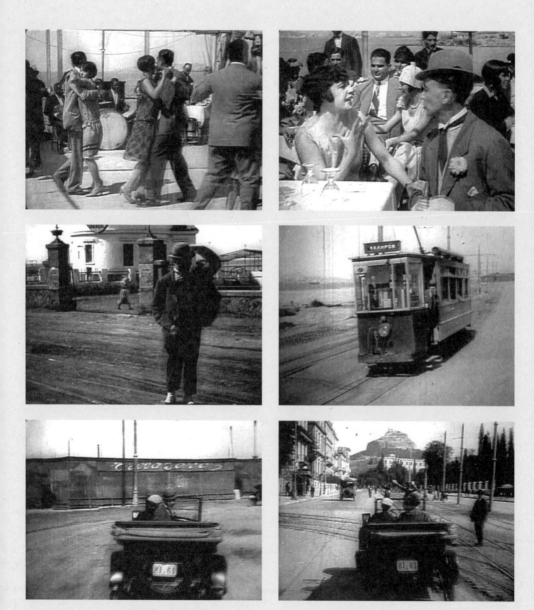

THE DRUNKARD/O METHYSTAKAS (1950)

LOCATION *5 Klepsydras Street, Anafiotika, Plaka*

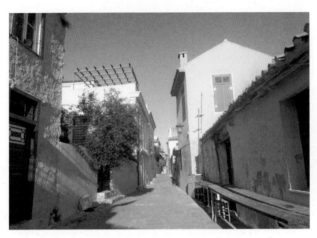

WRITTEN AND DIRECTED by Yorgos Tzavellas, *The Drunkard* was released in 1950 to almost universal acclaim. The film achieved the dual accomplishment of receiving recognition for its artistic merits as well as establishing a box office record that was to remain unparalleled throughout the 1950s. The film centres on the character of Haralambos, the drunk of the title played by Orestis Makris, an elderly cobbler who loses his son during the war on the Albanian front, only then to lose his wife who dies during the hardships of the Nazi occupation. Following these events, the old man neglects his daughter and business, spending his days and nights drinking in the tavernas of Anafiotika, that hodgepodge of small, white-washed cottages, built almost one on top of the other, up the slope of the Acropolis. Tzavellas's camera lingers lovingly on this nineteenth-century reconstruction of Cycladic island life. His Anafiotika is all steep steps and flat, vine-covered roofs, improvised window boxes, barefoot children and street sellers hawking their wares off the backs of donkeys. And, like the character of Haralambos, Anafiotika is an urban anomaly caught between the bustle and business of the modern post-war city below and the ancient ruins above. This imaginary village-within-the-city becomes a site in which to assess the economic drive of post-war reconstruction against the traditional values of an older generation. Haralambos and his drunken surrender to the ill-wind of fate embodies the sense of national confusion and disillusionment engendered by the chaotic years of occupation, resistance, famine and civil war, followed by rapid urbanization and unregulated re-development. When, in the end, he is knocked down drunk in the winding streets of the old town, it comes as no surprise that it is under the gleaming chrome of a stately, imported car. **↝Nick Potamitis**

Directed by Yorgos Tzavellas
Scene description: Haralambos tastes the new wine of the 'The Vineyard' tavern
Timecode for the scene: 0:02:02 – 0:04:43

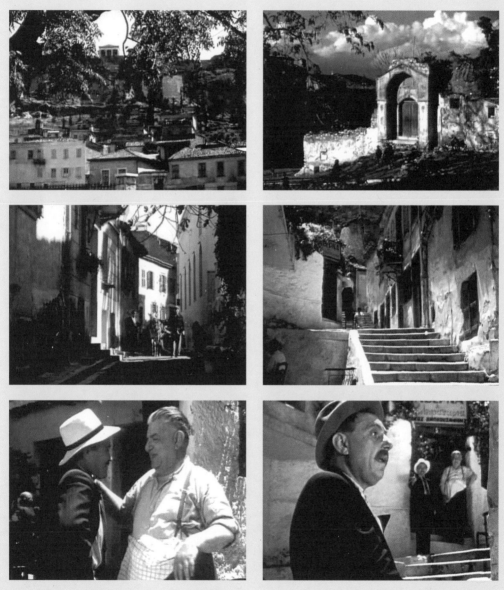

MAGIC CITY/MAGIKI POLIS (1954)

LOCATION *Syngrou Avenue, Dourgouti (Neos Kosmos)*

MAGIC CITY is Nikos Koundouros's debut film and one of the most notable examples of poetic realism in Greek cinema. The story of Kosmas, a poor lad struggling to make a living, is also a testimony to life in post-civil war Greece. The film is located in Dourgouti, a destitute area near the centre of Athens that housed émigrés and working-class internal immigrants since the 1920s. Koundouros films Dourgouti exactly as it looked at the time: a slum with cramped, miserable hovels, open sewers and muddy streets. However, the residents are shown as dignified, honourable, hard working and proud. This representation is juxtaposed with a certain image of the city: the glamorous yet seedy world of thugs, with its neon signs, beautiful women, jazz tunes, exotic dancers, quick money and guilty pleasures. Through the distinction between these two collateral worlds ('Magic polis' vs 'Magic City'), the film pays homage to the working class, which is shown to preserve traditional principles and values, and to manifest a certain wariness and scepticism towards western mores and lifestyles. Today, there is not much left of the old neighbourhood. In the mid-1960s, there was a big housing project, and the slum was torn down. Although living conditions have definitely improved, Dourgouti is still a poor area, hidden from public sight behind Syngrou Avenue and its towering buildings. People are largely low-income, immigrants and refugees, who came to Greece hoping to find their own 'Magic City' but the crisis has massively increased urban blight.
◆◆Yvonne Kosma

Directed by Nikos Koundouros
Scene description: Kosmas meets Maria in Dourgouti
Timecode for scene: 0:20:44 – 0:25:22

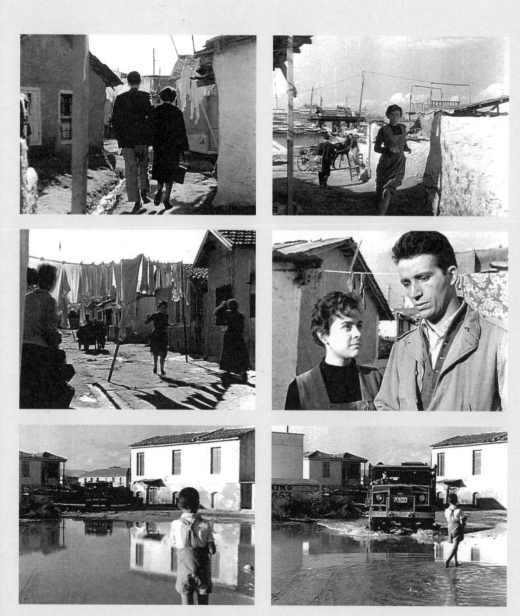

WINDFALL IN ATHENS/ KYRIAKATIKO XYPNIMA (1954)

LOCATION *45 Marasli & Xenokratous Streets, Kolonaki*

MICHAEL CACOYANNIS'S first film, *Windfall in Athens*, not only celebrates the uncontested thespian abilities of its exceptional protagonists (Ellie Lambeti, Dimitris Horn and Yorgos Pappas), but constitutes one of the first Greek, and European films, for that matter, that put the city on a par with the story's main heroes and heroines. Mina (Lambeti), a young employee in a hat shop, is robbed while at the beach and loses not only her modest possessions but also a winning lottery ticket. The ticket is then bought by Alexis (Horn), an aspiring young composer, who lives in a room he shares with two older women in Exarhia, one of the most bohemian Athenian neighbourhoods. However, before he finds out he is now a wealthy man, a sequence in the upper-class neighbourhood of Kolonaki prepares us for his sudden windfall. A long-shot from the foot of the steps leading up to the centre of Athens, shows Alexis working on a melody in the street. The shot reveals Lycabettus Hill, situated at the north-west end of Kolonaki, which unfortunately cannot be seen today, among the myriad buildings that have transformed the area into an extremely tight-spaced yet still cosmopolitan and expensive Athenian quarter. Alexis comes down the steps to the kiosk (the Greek 'periptero', a cultural staple on every street, selling anything from newspapers and cigarettes to candy and little toys). At 45 Marasli and Xenokratous Streets, he is unknowingly minutes away from Mina, who has found out that her stolen lottery ticket has won a great fortune and is running towards a lawyer's office to ask for help. Almost two and a half decades before New York's Upper East Side began 'accompanying' Woody Allen's romantic entanglements and insecurities, the elegant Athenian quarter of Kolonaki was already serving domestic romance.
↝ Betty Kaklamanidou

Directed by Michael Cacoyannis
Scene description: Alexis is wandering the streets of Kolonaki
Timecode for scene: 0:34:40 – 0:36:53

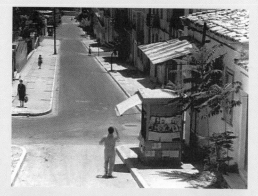
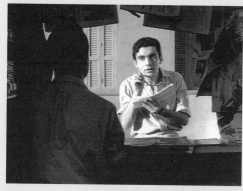
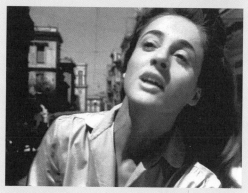
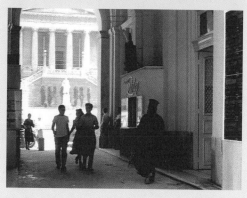

Images © 1954 Millas Film

THE COUNTERFEIT COIN/I KALPIKI LIRA (1955)

11 Herodou Attikou Street

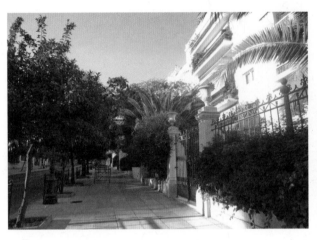
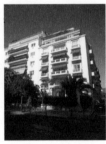

AN EPISODIC FILM, *The Counterfeit Coin* captures the image of a city in transition in terms of the effect of money upon social relations. An engraver makes a counterfeit gold sovereign that everyone can tell is fake. Thereafter, this coin becomes the means by which a supposedly blind beggar will win over a courtesan; it then enables a Scrooge-like miserly landlord to show his humane side to a poor orphan girl; and, finally, it becomes the only asset of a loving young couple, Pavlos (Dimitris Horn), a poor bohemian painter, and Aliki (Ellie Lambeti), a rich girl who has left her family to live with him in an attic, before poverty emphatically separates them. Each plot unfolds in several working- and lower-middle-class neighbourhoods, but also in squares and streets in the centre of Athens, which inscribe the characters in the changing urban landscape. At every turn, the narrative exposes, from a humanitarian, neo-realist point of view, the corrosive effect of money and how it leads to alienation. It is no coincidence that the film ends outside Aliki's house, on Herodou Attikou Street, one of the most beautiful, expensive and emblematic streets of Athens. Along its two sides lie the National Garden, the Presidential Mansion, the Cabinet Office and expensive apartments of wealthy families. It is there, seven years after their break-up, that the two former lovers meet by chance. They confess that their love remains strong, although Aliki is now married to a rich man of her class, whereas Pavlos has dedicated himself to his art. The narrator concludes that it was not the sovereign that was counterfeit, but money in general. On Herodou Attikou Street, home of the country's elite, it is ironically confirmed that money can't buy love. **⇢Stelios Kymionis**

Directed by Yorgos Tzavellas
Scene description: Pavlos and Aliki meet again after seven years
Timecode for scene:1:56:20 – 1:59:50

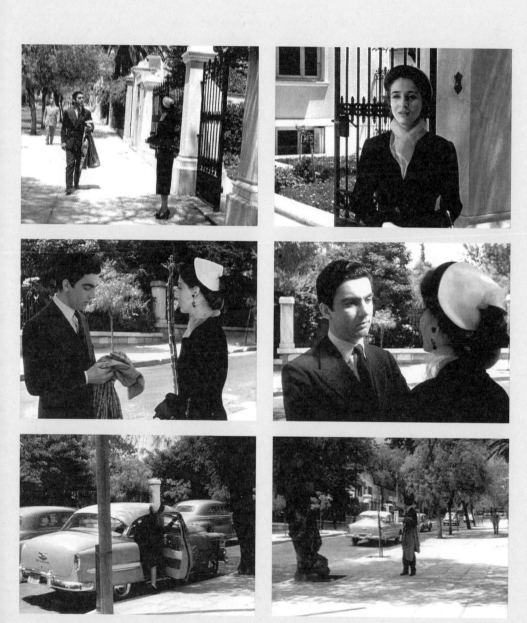

Images © 1955 Anzervos

NO HARM DONE/
OUTE GATA, OUTE ZIMIA (1955)

LOCATION *Café Select, 26 Fokionos Negri & Eptanissou Streets*

ALEKOS SAKELLARIOS'S film *No Harm Done* is a romantic comedy about sexual mores, with the flair of French boulevard theatre. In the film, adultery is represented as a whim of the bourgeois, as opposed to the simpler, less sophisticated yet more loyal country folk. This is very typical of films of that era, which seem to waver between a fascination with modernization and a certain fear of contamination and corruption from western customs. The opening scene is situated in one of the most fashionable and expensive neighbourhoods at the centre of Athens during the 1950s and 1960s. In a setting that connotes a privileged urban lifestyle, Nikos Koutroubas (Lambros Konstandaras) is trailing Poppy (Ilya Livykou), making fervent amorous advances towards her. At the time, Fokionos Negri Street was replete with cafes, pastry shops and restaurants, attracting intellectuals, writers, artists, film stars, as well as the affluent bourgeois. In those days, living downtown was an indicator of upward social mobility and westernization; but gradually the centre became so over-saturated that the new trend was to acquire property in the suburbs. Today, the once fashionable quarter still retains a particular charm of its own regardless of the economic crisis, which has accentuated the class-related demographic divide. The particular corner of Fokionos Negri and Eptanissou Streets is known for the Café Select, which was established in 1945 and is still popular, despite the growing downtown squalor that has been brought on by the recession. **◆ Yvonne Kosma**

Directed by Alekos Sakellarios
Scene description: Nikos is flirting with Poppy on Fokionos Negri Street
Timecode for scene: 0:01:38 – 0:02:49

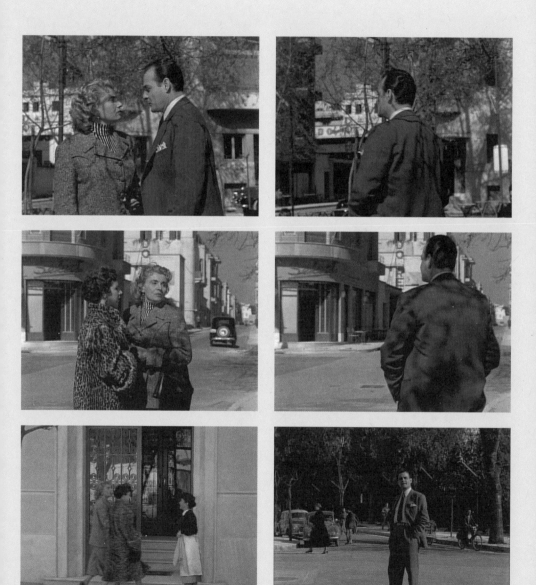

STELLA (1955)

Junction of Kallidromiou, Ekonomou, Deliyanni, Ioustinianou and Poulherias Streets, Exarhia

STELLA was the first Greek film to achieve international recognition. Stella (Melina Mercouri), a *rembetiko* singer at the Paradise taverna, is an independent, unconventional woman who does not want to marry. She falls in love with Miltos (Yorgos Foundas), a Cretan footballer, but when he gives her no choice but to marry him, she runs away, leaving him ridiculed waiting in the church. The film combines melodrama with neo-realist elements and poetic realism, while its focus on a female heroine, who is a symbol of women's emancipation, was provocative for its time. But what stands out in the film is the landscape. The film was shot on location in and around a bombed and scarred Athens after ten years of warfare. It is this ravaged landscape that resonates the lives, experiences and poverty of its inhabitants. The highlight of the film is the junction of Kallidromiou, Ekonomou, Deliyanni and Ioustinianou Streets in Exarhia, central Athens, where the final scene takes place. In this scene, although Miltos wants revenge, as he crosses the junction he warns her: 'I've got a knife' (words forever inscribed in Greece's cultural memory). But Stella does not run away; instead she crosses from the taverna on the corner of Ekonomou and Deliyanni Streets towards him, unable as well to escape her fate in a true fashion of Ancient Greek tragedy. In a series of close-up shots, they approach each other and he stabs her. Stella dies in his arms as they kiss. The film ends with a high long-shot of the junction. ⟿*Eleftheria Rania Kosmidou*

Directed by Michael Cacoyannis
Scene description: Miltos kills runaway bride Stella
Timecode for scene: 1:24:04 – 1:29:50

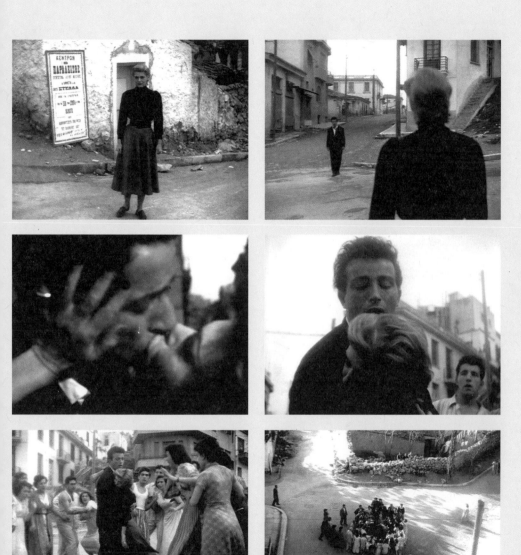

Images © 1955 Millas Film

THE GIRL FROM CORFU/
PROTEVOUSIANIKES PERIPETIES (1956)

LOCATION *Stadiou Street, Panepistimiou Street, Omonia Square, Syntagma Square*

THE GIRL FROM CORFU was the first Greek film ever shot in Eastman Color, although it was the second such one projected in public. The protagonist, Rena Vlahopoulou, one of the most important comedy actresses in the history of Greek cinema, in her screen debut, plays a young girl from the island of Corfu who is invited by her uncle to come to the 'big city of Athens' and get married. There are no cars on the island and so she rides into town on her donkey, not knowing that a new law had been passed prohibiting donkeys on the streets of Athens. In terms of form, the sequence is a music video (Vlahopoulou is singing) – one of the first ever shot in Greek cinema. It's pretty certain that the director, Yannis Petropoulakis, and his editor were aware of the 'City Symphony' genre of the 1920s: canted documentary shots are juxtaposed with medium-shots of huge cars, buses, traffic policemen and buildings that dominate the frame and, consequently, the city. All shots are quasi-POV shots of the protagonist who is singing and riding her donkey in the traffic jam and the crowded crossroads of Athens's biggest central avenues, Stadiou and Panepistimiou, that bridge the two major squares, Omonia and Syntagma. Indeed, the sequence depicts the most striking aspects of 1950s Athens, which also attest to the period of economic development that had just started in Greece (lasting from 1952 to 1973): the huge private and public blocks of buildings in the centre of Athens and the massive increase in traffic in the city streets which were too narrow to accommodate it.
➻ Yannis Skopeteas

Directed by Yannis Petropoulakis
Scene description: The girl from Corfu arrives in the centre of Athens on her donkey
Timecode for scene: 0:25:58 – 0:29:02

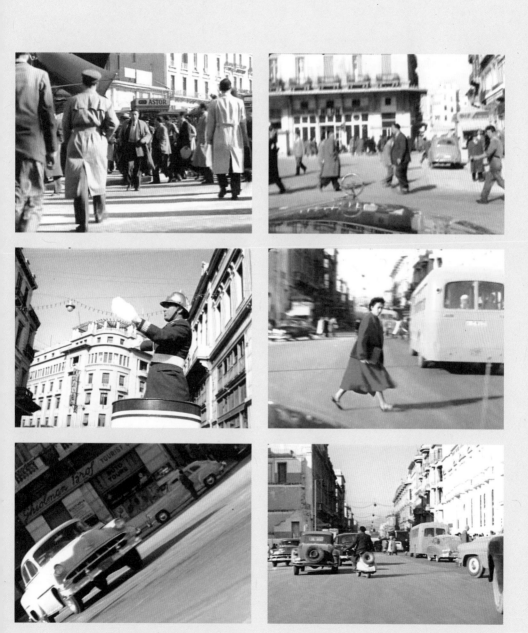

Images © 1956 Olympos Film, Peter Mellas, William Lambros

ATHENS IS BURNING

Text by
DIMITRIS
PAPANIKOLAOU

THE ACROPOLIS: to say that generations of Greek directors have been operating under its shadow would be an understatement. Greek directors of all kinds, from the most commercially minded to the most avant-garde and auteurist, have been faced with a conundrum when filming in Athens. If they offer a shot of the ancient rock, they are seen to be making an easy iconographic statement. On the other hand, not showing it at all could register as a conscious avoidance, pregnant with meaning. When a film like *Apo tin akri tis polis/From the Edge of the City* (Constantine Giannaris, 1998) came out, most reviewers pointed out that the film is set not in the Athens of the Acropolis, but that of the busy streets, the immigrants and the poor suburbs. Present or absent, a shot of the Acropolis has been the phantasmatic anchoring of Athenian cinematography for decades. The Acropolis seems like it has always been there, even when it ends up being deconstructed through the politics of

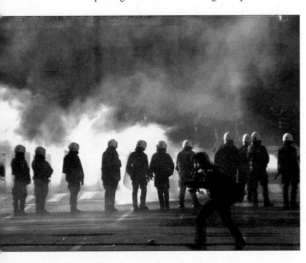

the gendered body (as in Eva Stefani's magisterial *Acropolis* [2001]), or the new queer film poetics of Panos H. Koutras (who has not yet made a film without referencing the ancient site, including showing it being absorbed by a giant moussaka, in his *I epithesi tou gigantieou moussaka/The Attack of the Giant Moussaka* [1999]).

Until 2008, that is. At which point, all of a sudden, the Acropolis-City was turned into one of the most recognizable global images of the City-in-Trouble. After the mass demonstrations that followed the killing of teenager Alexandros Grigoropoulos by police officers in December 2008 and with the financial crisis changing the cityscape dramatically, provoking a series of further demonstrations and scenes of popular unrest after 2009, a certain imagery of Athens-in-Flames became the new global visual cliché.

Like the Acropolis before it, the image of Athenian demonstrations has been so widespread globally after 2009, that, once again, it frames the reception of Greek films even where it is absent, as in *Kynodontas/Dogtooth* (Yorgos Lanthimos, 2009), *Alpis/Alps* (Yorgos Lanthimos, 2011), *Miss Violence* (Alexandros Avranas, 2013) or *Macherovgaltis/Knifer* (Yannis Economides, 2010). If Lanthimos is showing us houses closed off (in the wealthy suburbs of Athens?), empty factories, gyms and hospitals in *Dogtooth* and *Alps*, that stark urban landscape and the claustrophobia his films evince are taken as symbols of what the films don't show: the demonstrations happening in real life and in real time, just outside the enclosed world of these allegories and as the films were being produced.

The step bridging the two – the allegories of (national) enclosure on the one hand and the scenes of street revolt on the other – was influentially taken in 2010 by Syllas Tzoumerkas in

his *Hora proelefsis/Homeland* (Syllas Tzoumerkas 2010). This is a major film that focuses intently on an iconography of mass demonstrations in Athens, a feature that accounted for its international success. But the film's whole point is that it treats the images of demonstration and disruption not for their realistic, but for their allegorical qualities. Similarly to Lanthimos's films, the effort is to move from the torn public to the tattered private: the actual trouble is not in the city; it is in the family, in the body, in the dissonance of belonging. The trouble is also in the projections about cultural integrity and homogeneity that viewers may still expect from a Greek film coming out of the Crisis.

The response to films like *Homeland* shows that what a global audience wants from a post-2008 Greek director are scenes of demonstrators confronted by police in front of iconic buildings like the Greek parliament, shots of poverty, crowds assembling, state violence or insurrectionist chaos. Ironically, the global interest in images of disruption from Athens is directly related to the city's classicizing iconicity. The Acropolis still remains, only now a global audience is fantasizing about it being in flames. News magazines all over the world have even produced such images on their covers, often based on an easy reference to Hollywood disaster films (e.g.

the cover of the *Economist*, 1 May 2010, titled 'Acropolis now'; the collage is, of course, inspired by *Apocalypse Now,* [Francis Ford Coppola, 1979]).

Avant-garde Greek artists have been quick to pick up on the irony of these projections. The curators of the major exhibition 'Monodrome' (2011), for instance, showed videos and photographs from demonstrations in a derelict industrial building in the centre of Athens; the site's uninhibited view to the Acropolis was cleverly used as the exhibition's untold framing. And Yannis Karlopoulos, an Athens-based graphic designer, has printed postcards that show a touristic image of the Parthenon in flames (the smoke and flames superimposed on the ancient site are actually coming from well-known photographs of tear gas smoke or fires during post-2008 demonstrations). A number of video artists and directors have followed this lead, often with a humour that is perhaps lost on non-Greek audiences.

Film directors have also conversed with this frame of reference and even tried to exploit it. A good example is the commercial rom-com *An.../ What If...* (Christoforos Papakaliatis, 2012), a huge hit in the Greek box office of 2012–13. A love story that owes a lot to *Sliding Doors* (Peter Howitt, 1998), *What If...* takes place in the Athens of the Crisis (cut: shots of demonstrations and disruption), but it also settles in the picturesque neighbourhood of Plaka, in the environs of the Acropolis (cut: constant shots of the Parthenon in the background). Crisis chic. It is an easy association that the auteur film aesthetics of Constantina Voulgari both avoids and cleverly undermines in her *Synharitiria stous esiodoxous/ A.C.A.B. All Cats Are Brilliant* of the same year (2012). As the film opens, the main character, called Electra (!), cruelly-optimistic-in-the-midst-of-social/personal-crisis, walks through a dirty street in Athens. In the background we see insurrectionist posters and slogans written on the wall. She will enter the metro, join a demonstration (they pass in front of the parliament – middle shot of the building's neoclassical features), walk along more streets and encounter more slogans. Often in this film, you sense that if the camera had panned in the other direction, we would have seen the Parthenon in the background. It doesn't, and we don't. But the association and the conscious avoidance are cleverly there, for whomever knows their Athens; burning or not. ✢

Like the Acropolis before it, the image of Athenian demonstrations has been so widespread globally after 2009, that, once again, it frames the reception of Greek films even where it is absent.

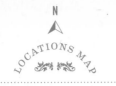

ATHENS

maps are only to be taken as approximates

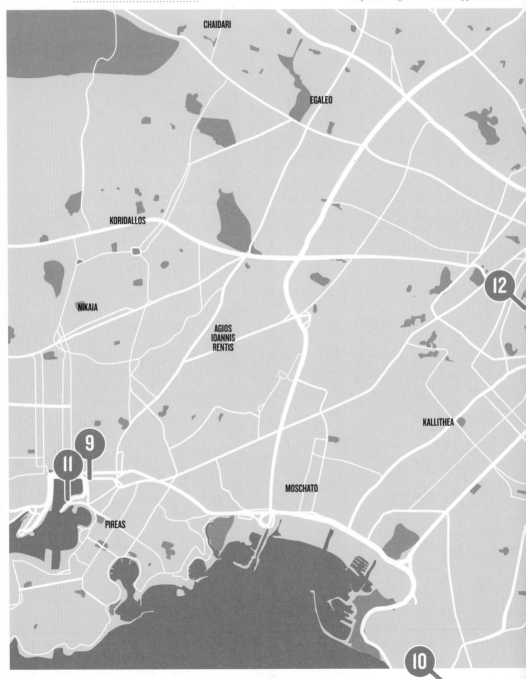

CHAIDARI

EGALEO

KORIDALLOS

NIKAIA

AGIOS
IOANNIS
RENTIS

KALLITHEA

12

9

11

MOSCHATO

PIREAS

10

ATHENS LOCATIONS
SCENES 9-16

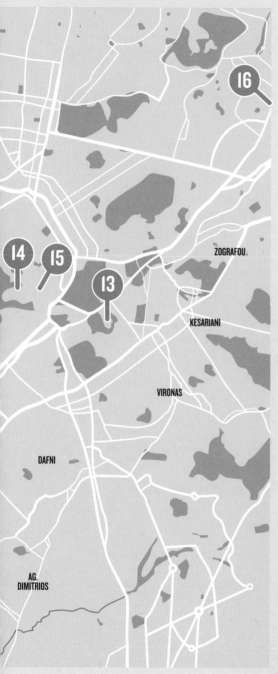

THE OGRE OF ATHENS/O DRAKOS (1956)

LOCATION *The Piraeus train station*

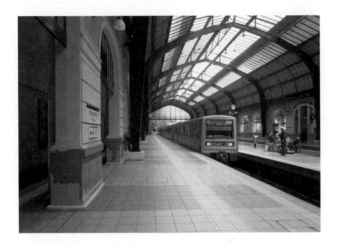

NO CITY ON THE OUTSKIRTS of Athens had such a special allure for Greek film-makers as Piraeus, the place readily associated with Greece's largest seaport, but also travel and paid love. Piraeus is the almost idealized space where American Homer Thrace is mesmerized by the carefree prostitute Ilya in Jules Dassin's *Never on Sunday* (1960) and where, in the now iconic *Zorba the Greek* (1964) by Michael Cacoyannis, the first encounter between the Boss and the quintessential Greek Zorba takes place. And yet, perhaps never before had the city acquired darker tones than in Nikos Koundouros's *The Ogre of Athens*, a film that draws on the film noir – even if with a sense of sarcasm – to provide a fine social satire of post-civil war Greece. The Ogre of Athens (alternative English title: *The Fiend of Athens*) follows a timid, penniless man (Dinos Iliopoulos) who, unlike the criminal in Fritz Lang's *M* (1931), is wrongly identified as a notorious fugitive fiend. In his attempt to escape his police persecutors, the poor man is gradually immersed in the criminal underworld. This is the life-threatening world of seductive courtesans and petty crooks who plan to sell 'the [Parthenon] marbles to the Americans'; above all, this is the place of alluring decadence, darkness and, ultimately, betrayal. When his real identity is revealed, the humiliated and abandoned hero roams the Piraeus train platform on his way from the idyllic 'elsewhere' back home. It is the film's tragic denouement that will ironically save him from his suffocating everyday life. ↪ ***Erato Basea***

Directed by Nikos Koundouros

Scene description: Thomas is released from the police and returns to Athens

Timecode for scene: 1:08:10 – 1:09:50

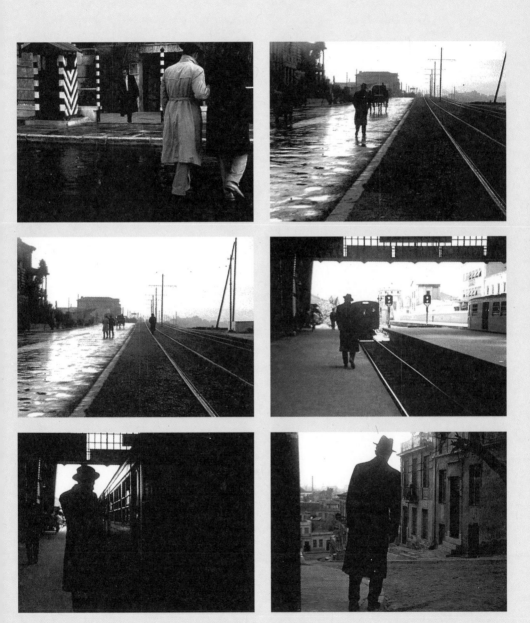

Images © 1956 Athinaiki Kinimatografiki Etairia (Athens Film Company)

BOY ON A DOLPHIN (1957)

LOCATION
"Astir" Beach & Resort Facilities, Glyfada, Athens

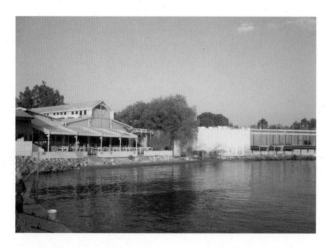

BLOCKED MARSHALL PLAN funds and the determination of Spyros Skouras, then President of 20th Century Fox, to help his homeland brought Hollywood to the shores of the Aegean. Loosely based on David Divine's novel by the same title, Negulesco's film, featuring a multinational cast (Alan Ladd, Clifton Webb and Sophia Loren), echoes the successful recipe of his *Three Coins in the Fountain* (1954). Exterior shots were filmed between September and October 1956, while interior shots were completed at Cinecittà, Rome, later that year. The film boasts two main film locations: the island of Hydra and Athens. Additional filming took place at Epidaurus and a monastery at Meteora. Athens is portrayed in five sequences, two of which focus on the city's 1950s cultural and tourist infrastructure. The first showcases the recently completed reconstruction of the Stoa of Attalos (1951–56), carried out by the American School of Classical Studies in Athens, and the Acropolis Museum (1954–58), newly renovated by architect Patroklos Karantinos. This constitutes one of the few instances that the Central Archaeological Council, Greece's chief advisory authority on monuments and sites, granted permission for shooting with actors at the Parthenon. The second sequence depicts Athens's emergent landscapes of modernization: in particular the Astir Beach and Resort Facilities (1955–58) designed by architects Prokopis Vassiliadis, Manolis Vourekas and Periklis Sakellarios at Glyfada. Three months into its operation, the Asteria restaurant and nightclub – an elegant succession of indoor, semi-outdoor and outdoor spaces, featuring a fully visible timber framework, marble stone non-bearing walls and aluminium sheet roofs – became the ideal backdrop for Greece's transition to a modern society and Athens's corresponding transformation into a contemporary European capital. **→Stavros Alifragkis**

Scene description: Phaedra is trying to sell the ancient statue of a boy riding a dolphin to an art collector
Timecode for scene: 0:22:56 – 0:28:21

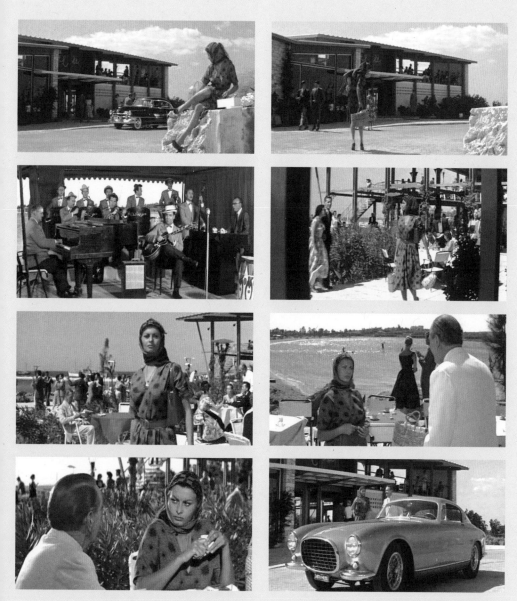

NEVER ON SUNDAY (1960)

LOCATION *Karaiskaki Square, Piraeus*

NEVER ON SUNDAY is a Pygmalion-type narration with Homer (Jules Dassin, also directing), an American amateur philosopher, striving during his visit to Greece to transform the carefree prostitute Ilya (Melina Mercouri) into a cultivated, 'honest' lady. Behind this myth, the controversy between Greece's glorious past and the decadent present is highlighted, making the film emblematic of the 'branding' of Greece which took place from the 1960s onwards. An expert at choosing shooting locations (his *Naked City* of 1948 was shot in 100 different locations in New York), Dassin chose Karaiskaki Square in the Port of Piraeus to carry the social subdiscourse of the film. This is established when a group of prostitutes meet there with self-employed Ilya, to get her support against their pimp. Incidentally: Karaiskaki Square looks less like a 'square' and more like a construction site. The square was named after Georgios Karaiskakis, who liberated Piraeus from the Ottomans in 1827, and was the location of the slums that housed the refugees from Asia Minor in the early 1920s. By the late 1920s, the whole area was destroyed by fire. In the late 1950s, it was functioning as a pier, with reconstruction being carried out, to be completed in six years' time. In this film, in a performance that won her an award at Cannes, Mercouri became established internationally as one of Greece's representative icons. But it is this setting where Ilya's open mockery of the pimp's stooge takes place that reinforced Mercouri's political networking with the city of Piraeus, where her political career began after 1974. ↝ *Athena Kartalou*

Directed by Jules Dassin
Scene description: Ilya takes the bus from Piraeus to the Herod Atticus theatre
Timecode for scene: 0:37:00 – 0:39:00

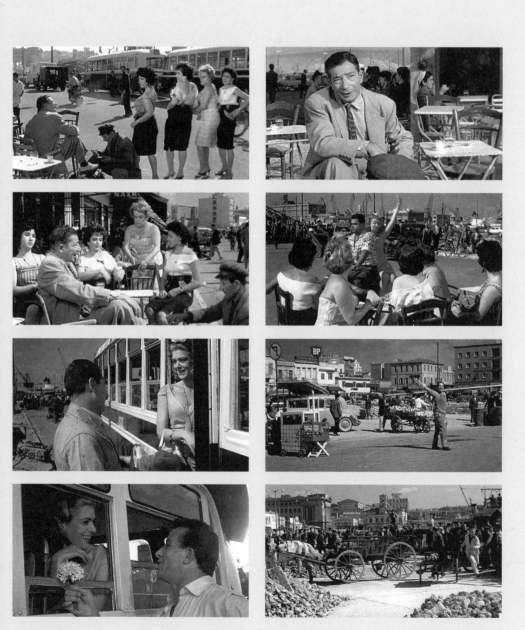

Images © 1960 Lopert Pictures Coproduction, Melina Film

DREAM NEIGHBOURHOOD/SYNIKIA TO ONIRO (1961)

Stisikleous Street, Filoppapos Hill

IT IS NO COINCIDENCE that the opening credits sequence of *Dream Neighbourhood* tells the untold story of a whole country in a just few minutes. The neighbourhood of Asyrmatos in Ano Petralona, an 'exiled' shanty town that stretched out from the bottom of Filopappos Hill and consisted of the makeshift homes of 800 refugee families from Asia Minor, was a version of Greece no one wanted to acknowledge. Just as the government of the day, which censored the film, claiming it was a defamation of the supposed Greek Economic Miracle that had been underway since the mid-1950s. In the first and only film actor Alekos Alexandrakis ever directed, and one of Greek cinema's best, one sees the influence of Italian neo-realism and the need for a daring film-maker to focus on the open wounds of the Greek Civil War, at a time when local cinema cared only for cheap melodrama and comedies for mass consumption. The protagonist of the film, the frenetic neighbourhood of Asyrmatos, becomes the real-life setting of a movie about survival, while nearby, Athens had its sights set on its 'promising' reconstruction, burying the dreams of a whole generation under the concrete of large apartment buildings. Even today, you needn't fly as high as the kite in the film's opening and closing scenes to get a bird's-eye view of a city which has been built over the ruins, both inanimate and living, of different eras. **⇢Manolis Kranakis**

Directed by Alekos Alexandrakis
Scene description: Released from prison, Rikos returns to his neighbourhood
Timecode for scene: 0:00:39 – 0:04:20

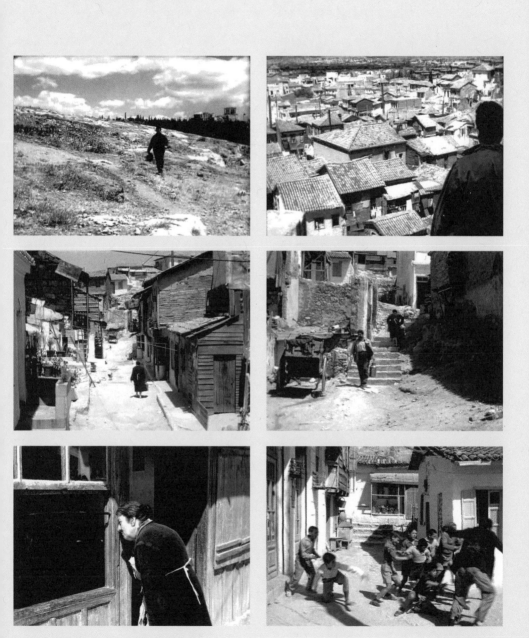

IT HAPPENED IN ATHENS (1962)

LOCATION

Panathenaic Stadium, aka Kallimarmaron, Vassileos Konstantinou Avenue

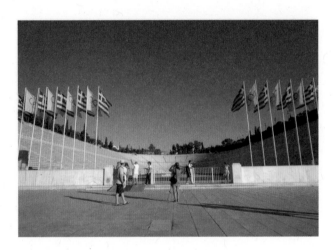

THE PANATHENAIC STADIUM is a proper diva – feathers, tiara and all – in Andrew Marton's *It Happened in Athens*, a charmingly camp attempt to recount the first modern Olympic Games in 1896. This means that the Stadium hosts most of the action, i.e. sequences of various sports events and quaint anecdotes that underscore the characters' cultural differences. The story (so absurdly naïve, it is almost delightful) centres on the young shepherd Spyridon Louis (Trax Colton), who decides at the very last minute to run the Marathon. Upon arriving in Athens, he falls in love with Christina (Xenia Kalogeropoulou), who works for the famous actress Eleni Costa (the ticking sex bomb that was Jayne Mansfield), who in turn is engaged to Alexis Vinardos (Nico Minardos), Greece's main contender for the Marathon. In this sequence, Louis, whose request to join the Marathon has been rejected by the Olympic Committee, has come to the stadium to gather his thoughts. Mesmerized by his surroundings, he walks around in a daze. Slowly, he starts to run. He's the David before the Stadium's Goliath, gazing at the white tracks that stretch out toward an unknown future. Manos Hadjidakis's music swells as Louis picks up the pace, but then the tempo suddenly slows down as he comes to a halt, disillusioned and hopeless. This is the only time we see the entire venue empty. There is also the final sequence – where Spyridon, by now a hero, reunites with Christina – which includes shots of the empty amphitheatre, but these are confined to the seats and not the running tracks. But there's no need for them. The tracks leading to Louis's future had already become history. ↔*Elena Christopoulou*

Directed by Andrew Marton
Scene description: Spyridon Louis is training in the empty Stadium
Timecode for scene: 0:53:48 – 0:55:30

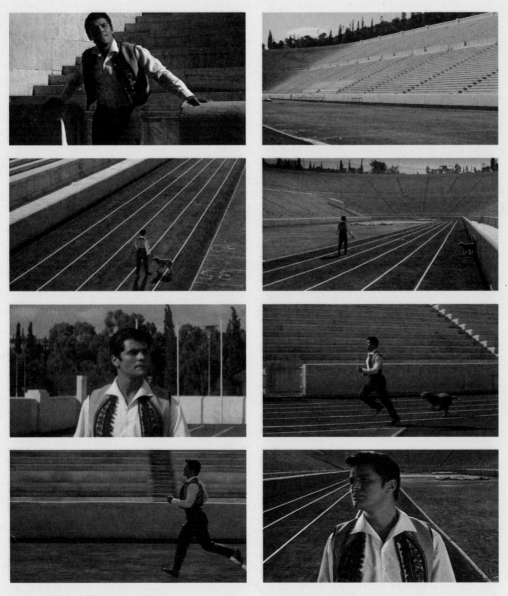

IN THE COOL OF THE DAY (1963)

The Acropolis

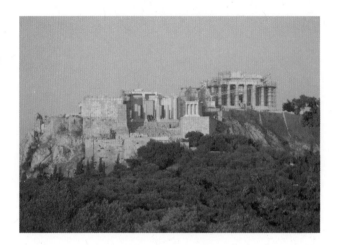

A MELODRAMA OF LUSH COLOURS and histrionic passions, *In the Cool of the Day* is loosely based on a romance novel by Susan Ertz. Christine (Jane Fonda), the wealthy but sickly young wife of an American executive of an Anglo-American publishing company, is suffocating under her husband's over-protectiveness. She and middle-aged Murray (Peter Finch), a British senior employee of the company and friend of the husband, develop a mutual attraction. Also trapped in an ill-matched marriage haunted by trauma, Murray is forced to chaperone Christine on the trip to Greece for which she has long yearned, bringing along his volatile wife, Sybil (Angela Lansbury). The film operationalizes a Cold War melodramatic aesthetic that confines Greece – then NATO's Balkan ward, wracked by political conflict and western interference – in exotic timelessness. Greece's timelessness is differentially coded in the film: sites of classical antiquity, with the Acropolis as their supreme representative, are associated with spiritual transcendence, while spaces occupied by Modern Greeks with earthy exuberance. In keeping with the international reputation of the Acropolis, it is the first tourist site the odd trio visits upon arriving in Greece. Christine and Murray's special affinity is reflected in their shared awe at the sight of the Parthenon (shot from low angles for a soaring effect), juxtaposed with Sybil's hilarious indifference. In the soundtrack, the Acropolis visit, as those to other ancient sites, is scored without making reference to the musical theme contributed by Manos Hatzidakis, which is reserved for the opening credits and for scenes involving 'natives'. The tight coordination of narrative, visual and acoustic elements (down to the colour palettes of the women's wardrobes) does not preclude ironic distancing. In the closing shot of the scene, a neon sign advertising the 'superior white' of a toothpaste stands out against the distant evening view of the rock. •◦ *Vassiliki Tsitsopoulou*

Directed by Robert Stevens
Scene description: Christine Bonner, Murray Logan, and Sybil Logan visit the Acropolis
Timecode for scene: 0:39:26 – 0:41:56

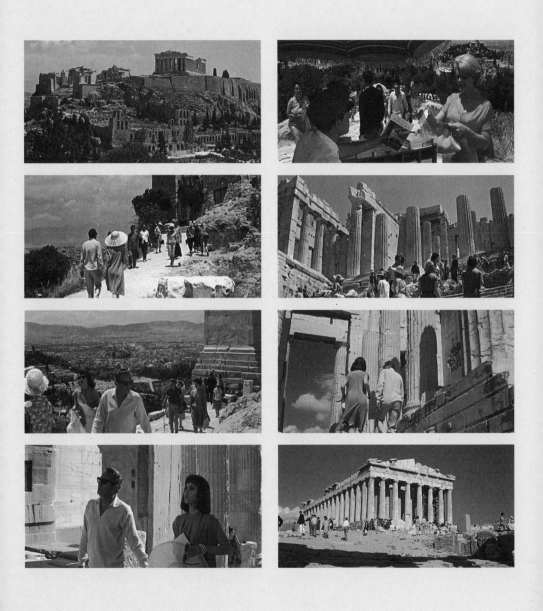

THE WIFE SHALL FEAR THE HUSBAND/
I GYNI NA FOVITE TON ANDRA (1965)

LOCATION *32 Tripodon Street, Plaka*

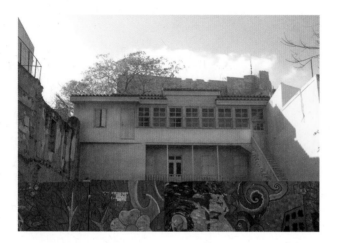

THE THEME OF the post-war transformation of the Athenian cityscape was obsessively developed by Yorgos Tzavellas in all his films. His last film, *The Wife Shall Fear the Husband,* is an example of an anti-modern discourse that invaded filmic representations of the Greek capital in the 1960s, rejecting the results of urban reconstruction. In this film, Tzavellas idealized vernacular architecture and everyday life in a working-class neighbourhood threatened by modernization. The demolition of the old traditional house where the main character, Antonakis (Yorgos Konstandinou), used to live, triggers a flashback to the years he spent with his girlfriend Eleni (Maro Kondou) before their failed marriage. The flashbacks of this idyllic past are juxtaposed with contemporary scenes of the modernized city centre complete with traffic jams, rude pedestrians and large-scale, alienating office buildings filmed in a negative way. Even worse for conservative Antonakis, the city's modernization also affects gender relations: Eleni abandons her servile attitude and begins contesting his masculine dominance, which leads to the disruption of the domestic balance. The building where the film was shot can still be located under the shadow of the Acropolis at 32 Tripodon Street in the tourist area of central Plaka and it is one of the most emblematic surviving examples of Ottoman vernacular architecture, selected as a case study by the architect Aris Konstantinidis in his monograph about old Athenian houses, published in 1950. Criticizing aggressive reconstruction, urban alienation and male anxieties of the 1960s, Tzavellas created with this film the archetype of cinematic urban nostalgia for pre-reconstruction Athens and exemplified an idyllic image of the traditional community of the shared courtyard of working-class housing. ⇢ ***Anna Poupou***

Directed by Yorgos Tzavellas
Scene description: Antonakis with his neighbors in the courtyard
Timecode for scene: 0:23:10-0:24:08

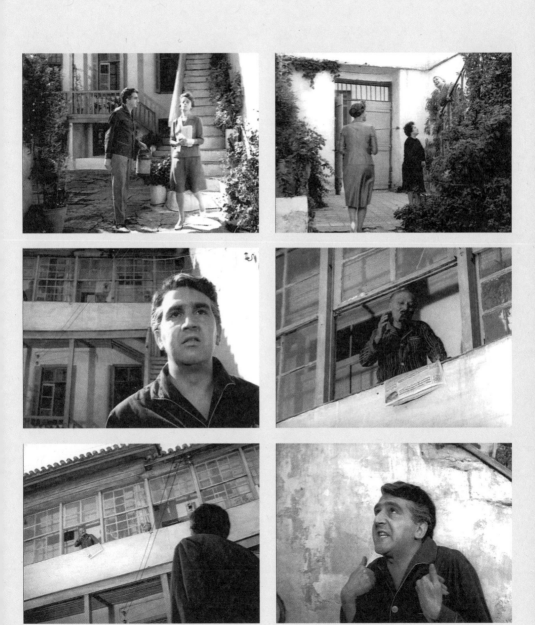

FACE TO FACE/PROSSOPO ME PROSSOPO (1966)

LOCATION *Six storey apartment building by architect Christos Vassilakakis, 38 Kifissias Avenue*

KENNETH FRAMPTON described Athens as a modern city par excellence, as, in the 1950s, a modern typology, outlined in the 1930s, rapidly devoured the nineteenth-century neoclassical city. The modern city expanded by means of the monotonous repetition of a single unit: the residential block of flats. By the mid-1960s, the Athenian apartment building had acquired a standardized morphology: pilotis, linear balconies, penthouses, terraces. Furthermore, novel construction techniques and materials (concrete structural framework, marble cladding, aluminium window frames, glass), as epitomized in the construction of the Athens Hilton (1958–63) by the architects Prokopis Vassiliadis, Manolis Vourekas and Spyros Staikos, became typical elements of architectural expression. The Athens Hilton features prominently in the film as the constant reminder of a modernist ideal that freely interpreted the indigenous classical architecture. Manthoulis critically reconstructs a Kuleshovian 'artificial landscape' of modernity, as he gleans instances of the prominent architectural paradigm of the time from different projects in Athens. One such project is the apartment building at 38, Kifissias Avenue, which consists of two separate blocks of flats joined over the recessed entrance hall, giving to a back garden and demarcated by a V-shaped pilotis. Manthoulis's protagonists occupy the penthouse, which, among other modern amenities, offers 'magnificent' views of the Parthenon, tightly framed by Athens's jagged skyline. This compromised and slightly skewed outlook on the glorified ruins of antiquity constitutes an integral part of Greece's modern condition. Manthoulis's sociopolitical critique was received warmly in Greece and abroad, however, the film was banned by the Greek junta's censorship board.
↝Stavros Alifragkis

Directed by Robert (Roviros) Manthoulis

Scene description: Dimitris, an English teacher, visits the apartment of Varvara, one of his students
Timecode for scene: 0:03:04 – 0:04:20

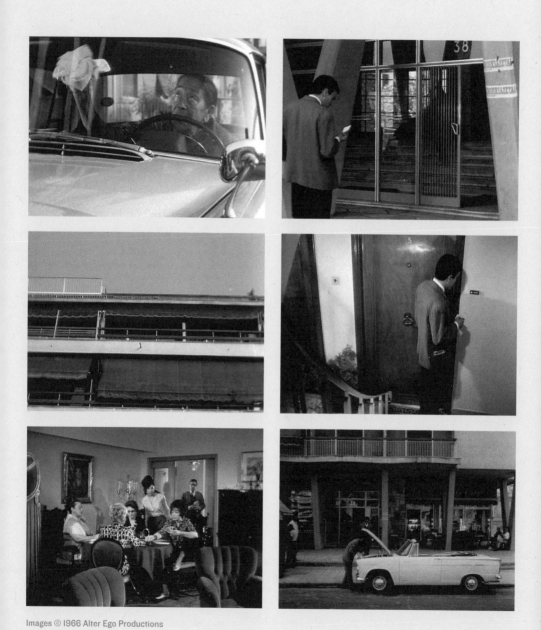

NIKOS PANAYOTOPOULOS'S ATHENS

Text by
ATHENA
KARTALOU

From Relic of Antiquity to Hipster Urban Refuge

NIKOS PANAYOTOPOULOS is one of the most prolific directors in Greek cinema: he has produced fifteen films in 39 years, starting in 1974, an emblematic year both for the state affairs in Greece – the fall of the dictatorship – and for Greek cinema itself – the end of the studio era. Over these years, Panayotopoulos has created his own, unique cinematic universe, which carries the seal of an *auteur veritable*: somehow and obliquely a step away from the others, nevertheless ironic, and, almost always, unconventional and unpredictable.

His strongest and most recognizable auteur characteristic, however, is the creation of a self-reflective cinema under the influence – but not a strictly imitative one – of the French *nouvelle vague*. Even when, in the late 90s, he began observing a 'normalized', non-arbitrary narrative flow, that was only the pretext for developing further a personal cinematic apparatus consisting of genre exploitation and pastiche, ironic glances both at his surrounding reality and cinema itself, and a dominative set of high production values with an emphasis on the visual through art direction and cinematography.

In this universe, the heroes are just navigating through, deceptively appearing at the centre of the cinematic narration. Therefore, they seem often to be coming from nowhere and to be going nowhere. Why is this? The aim of their existence, i.e. the reason for the narrative itself, is to become the vehicle by which to reveal the auteur's cinematic vision. Nevertheless and historically 'inevitably' in the context of a self-reflective cinema, these heroes circulate in a pragmatically recognizable setting which they are so strongly connected to – it is in fact the only case in which they stop belonging to

'nowhere' – that the setting itself is elevated to the level of a cinematic protagonist: the setting fulfils the heroes; the setting fulfils the story.

The most beloved and often used scenery in Panayotopoulos's films is the city of Athens, gradually gaining ground in his work not as a background tapestry or as an imitation of the Godard-loved-Paris scheme, but in a proper leading role. Obvious proof of his devotion to his city is the so-called 'Athens trilogy', consisting of the films *Pethenontas stin Athina/Dying in Athens* (2006), *Athina-Constantinoupoli/Athens-Istanbul* (2008) and *Ta oporofora tis Athinas/The Fruit Trees of Athens* (2010) – all films with the name of the city in their titles.

Still, the introduction of the Athens leitmotiv goes further: in his first work, *Ta hromata tis iridos/The Colours of Iris* (1974), the upper-class centre of the city (Kolonaki) and the relic of antiquity (the Temple of Olympian Zeus) both appear, constituting one of the most 'constant' representations of the city in the early post-junta era. Later on in his career, Panayotopoulos seemed to rediscover Athens: from 1997 onwards, he reinforced his relationship with Athens, making the city the unifying element in his effort to establish a classical-type narration. This is a time when the city of Athens started playing a more important role in a number of Greek films, not to mention the fact that, within the next five years, this aspect of Greek cinema established itself as a distinct area in Greek film studies. Over the past fifteen years, each one of Panayotopoulos's movies taking place in Athens explored a different part of the city, a different 'Athens'. His heroes, who are always male, might still come from nowhere before the film and might still end up nowhere after the

film, but during the film they 'belong' to the city, though they never cross paths with each other. Every character belongs to a different social class; thus, since these heroes do not share the same class, they cannot share the same part of the city – this seems to be Panayotopoulos's view.

The protagonist of *O ergenis/The Bachelor* (1997), a 30-year-old, middle-class, non-motivated bank employee, is trying to find his wife, who has left him to become a prostitute, and circulates between his home in 'Apollon', one of the few skyscrapers in Athens; his neighbourhood of Ambelokipi, close to the city centre; the swank bars ('Rock'n'Roll') in upscale Kolonaki; and the unidentifiable roofs of the city: this is an Athens of ambition and greed, trying to achieve easy money and success, according to the dictates of the lifestyle magazines of the era.

In *Afti i nyhta meni/Edge of Night* (1999), the protagonist is a lower-middle-class owner of a kiosk, in his late twenties, jealously in love with an ambitious, aspiring singer. He circulates in the southern part of the city (the port city of Piraeus), along the *paraliaki* (the coast road), near the train tracks and the airport, until he leaves Athens to follow his girlfriend on her journey from one seedy provincial nightclub (the so called *skyladiko*) to the next, all over Greece. This is another Athens, striving to lift off from mediocrity to stardom, but the joy of song in the city turns into

The most beloved and often used scenery in Panayotopoulos's films is the city of Athens, gradually gaining ground in his work not as a background tapestry or as an imitation of the Godard-loved-Paris scheme, but in a proper leading role.

the lumpen hell of *consommation* (semi-prostitution) in rural Greece.

Upon his arrival in the city, the protagonist of *Delivery* (2004), an almost mute young man apparently from rural Greece and with no credentials, tries with the help of a map to find his way in downtown Athens (the National Road entering the city, Tris Gefyres, Kolokotroni Street, Patission Avenue, Omonia Square, Athinas Street), circulating among the drug addicts, the immigrants, the homeless: this is a hidden, uncomfortable Athens, the backstage of the 2004 Olympic Games euphoria.

The protagonist of *Dying in Athens*, a middle-aged, successful art history professor with a wife and two lovers, who is suffering from an aggressive form of cancer, circulates in the upper-class centre of the city (Panepistimiou Street, Kolonaki, Valaoritou Street, Klafthmonos Square): this is an Athens of wealthy culture and unfulfilled Epicureanism, covered by snow, and as such perhaps the most obviously removed from a realistic representation of the city; perhaps the one that best expresses the inner conflicts of the entire country just before its descent into the financial crisis.

Finally, the main protagonist of *The Fruit Trees of Athens*, a writer, sends his fictional creation, a naïve young man in his early thirties, constantly out in the streets of the city and its extensions (Neapoli, Lycabettus Hill, Vassilissis Sofias Avenue, Paleo Faliro, Syngrou Avenue), in order to savour the taste of its fruits: this is a nostalgic, back to basics, 'grounded' Athens, a hipster urban refuge in a time of crisis.

If one brings together these heroes and the parts of the city they walk through over time, one gets an idea of the male social stratification of Athens and can put into place the main pieces of the uncompleted puzzle/map of the city over the past fifteen years. But this is not the 'real' city; it is not even a documentary representation of the city – although in some cases it might seem so (*Delivery*). By unfolding a multilayer representation of Athens in consecutive films, Panayotopoulos, loyal to his love of self-reflective cinema, expresses a clear vision not of the city itself, as it might seem initially, but of the arbitrary city of cinema itself. Thus, the city cannot but emerge as a distinct pole in the interpretation of this phase of Greek film production, dominated up until now by readings of politics and society; a persistent characteristic of one of the strongest and most constant voices of Greek cinema of the post-studio era. ✣

CHAIDARI

EGALEO

KORIDALLOS

NIKAIA

AGIOS
IOANNIS
RENTIS

KALLITHEA

MOSCHATO

PIREAS

17

ATHENS LOCATIONS
SCENES 17-24

KIERION (1968)

Hellinikon Airport, Poseidonos Avenue,
War Cemetery for the Allied Forces of World War II

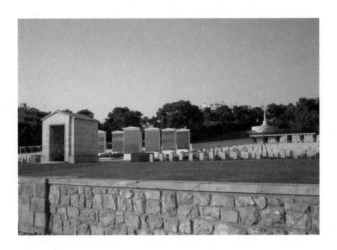

SHOT IN 1967, just before and in the early days of the dictatorship, *Kierion* by Dimos Theos was the first openly political Greek film that heralded the rise of a New Wave generation of film-makers, who reinvigorated Greek cinema. The title – an ancient town that lost both its freedom and name under successive occupations – suggests the political and economic dependency of Greece. It is precisely this sense of oppression and lost identity that is reflected in the film's depiction of Athens as a labyrinthine, extremely dark or unbearably sun-scorched wasteland, and as a protagonist in a story of violent deaths, para-state activity, political intrigue and police brutality. A Greek journalist collects his American colleague (who is later found killed) from Hellinikon Airport. The two men leave this symbol of modernity and drive along Poseidonos Avenue, better known as the *paraliaki* (the coast road), towards the centre of Athens. To the sound of the men's sinister discussion about international politics and financial interests, the camera rejects any escapist seaside shot, focusing instead on construction sites, the War Cemetery for the Allied Forces of World War II and the Athens Memorial, moving lorries, a gas station, the bleak buildings of the Keranis tobacco factory and the Fix brewery, as well as newly-built apartment blocks. Notorious today for its nightlife, in *Kierion*, the area surrounding Poseidonos Avenue is a wounded land of war memories, violently imposed modernity and national dependency, for not only did the Allies become Occupiers in the public consciousness after the war, but the greater area of Helliniko was also linked to the US military base located there. **↝ Maria Chalkou**

Directed by Dimos Theos
Scene description: The arrival of an American journalist at Hellinikon Airport
Timecode for scene: 0:04:43 – 0:08:18

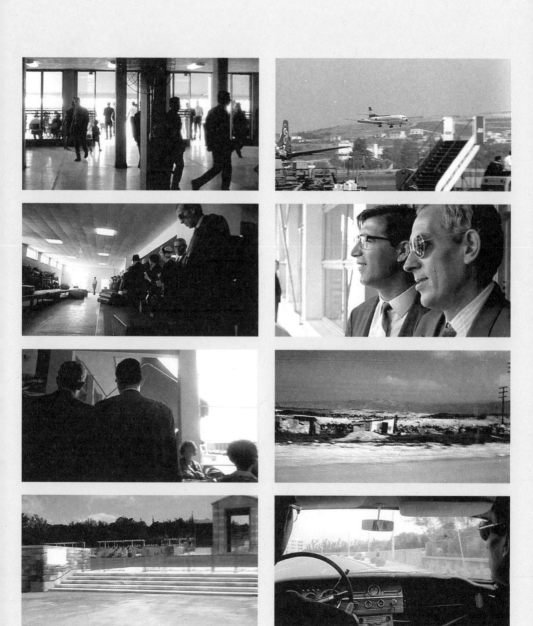

THE BURGLARS/LE CASSE (1971)

LOCATION *Athens Hilton, 46 Vassilissis Sofias Avenue*

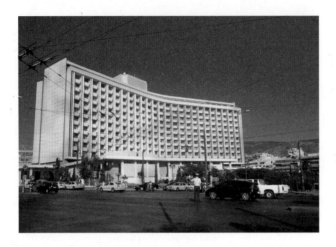

HENRI VERNEUIL'S iconic Euro-crime caper lands in Athens with a brief glimpse of the Parthenon, but soon we see a more cosmopolitan building casting its long shadow. Starring Jean-Paul Belmondo (Azad) as a street-smart burglar who steals an emerald collection but is chased by local corrupt police officer Omar Sharif (Zacharia), who wants everything for himself, *The Burglars* holds a pivotal role for the Athens Hilton, the first international hotel in Greece, which opened on 21 April 1963 in the presence of Conrad Hilton himself, who considered it 'the most beautiful Hilton Hotel in the world'. At first, the overwhelming structure in downtown Athens looked as if it had landed there from another planet, divided Athenians and was even accused of obstructing the view of the Parthenon. But soon it became a beloved symbol of luxury, modernity and a new prosperous era for the city. Azad enjoys the comfort of the legendary Galaxy Bar on the top floor with its breathtaking views of the city, where he receives a phone call from his girlfriend and partner in crime Helene, but also flirts with classy model Lena (Dyan Cannon). In this scene, Azad is caught red-handed by his jealous girlfriend, now calling him literally from the other side of the bar to warn him about Lena. Helene runs after her, only to realize that the lobby is swarming with policemen. Verneuil masterfully makes Azad's exit a literal descent, a vertical movement from a place in the clouds, down through the 'hidden' infrastructure of the building, the enormous kitchen and the laundry room, to a narrow escape through the back door. Clearly Azad belongs more to the very real traffic-jammed streets of Athens. **⇢ Lefteris Adamidis**

Directed by Henry Verneuil
Scene description: Azad tries to escape from the Hilton Hotel and avoid the policemen who are after him
Timecode for scene: 1:18:00 – 1:23:00

JOHN THE VIOLENT/IOANNIS O VIEOS (1973)

LOCATION *Omonia Square*

TONIA MARKETAKI'S *John the Violent* is about the murder of a woman, the police investigation, the sensationalization of the crime by the press, the moral panic caused by the psychopathic killer, and eventually the trial of John, who confesses and is sentenced to be confined to a mental asylum. Crossing the threshold of New Greek Cinema, Marketaki casts light on the intersection between society and the individual and on the fleeting substances of truth, time and madness. She does not convey the truth of a psycho-killer, but the social, judicial, cultural and existential values and regimes of truth that are in transitory collision in post-war Greece. Due to internal migration and the interpolation of modern lifestyles, Athens in the 1960s is transformed into a peripheral metropolis. Its central square, Omonia, is flooded with nervous crowds and is the core of its modern public sphere. In this sequence, Marketaki inserts John's voice reading the newspaper over shots of the newsstands in Omonia and the thronging crowds, and cross-cuts with shots of him reading in silence in his room. The newspaper report of the victim's depraved sex life, spiced up with rumours and hearsay, betrays a public opinion that still observes the Mediterranean code of honour and shame. However, when in a blink of an eye John confesses, the style of the news stories then shifts to the morbid modern fascination with the psychopathic killer, which grips the youth of the day and even John himself, who enjoys becoming a media legend, though alas, a murderous and transient one.
⇥ Ioulia Mermigka

Directed by Tonia Marketaki
Scene description: John is reading the rumours published in
the newspaper about the victim's depraved sex life
Timecode for scene: 0:57:34 – 0:58:58

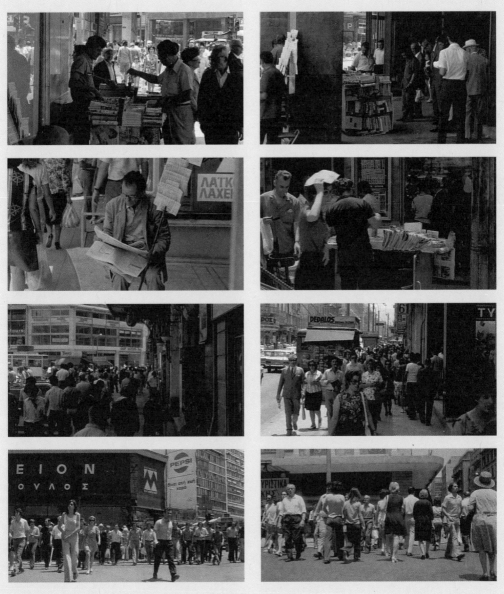

Images © 1973 Tonia Marketaki

THE COLOURS OF IRIS/
TA HROMATA TIS IRIDOS (1972)

LOCATION

Zonar's Café, 9 Voukourestiou Street & Panepistimiou Avenue

THE DEBUT FEATURE of Nikos Panayotopoulos is a magical and absurd tale of a man in search of his identity, set in 1970s Athens during the military dictatorship. In this timely fable, a music composer also named Nikos witnesses the mysterious disappearance of an unknown passer-by who vanishes into the sea during the shooting of a film. Nobody seems to care, but Nikos is determined to find out what happened to the missing man at all costs. Political by nature and cinematic by conviction, *The Colours of Iris* pays an idiosyncratic homage to the *nouvelle vague*. Flirting with the noir and the musical, the film playfully denies categorization and imbues all settings with humour and irony. In the scene in question, Nikos meets an 'informant' at Zonar's cafe, only to find out that the man he is meeting is a woman in disguise. She leads him to the toilets, where she starts kissing him and then cries 'rape!' Nikos manages to run outside and escape the trap. Zonar's, one of the most celebrated cafes in Athens, is a place rich in allure: founded in 1939 and modelled on the French cafes of the era, it was frequented by artists, intellectuals and upper-class Athenians. In 1974, Zonar's was already past its prime, and the fact that Panayotopoulos chooses it as a meeting point and then invites all the action into the restroom is indicative of his fondness for the bourgeoisie. Nevertheless, it is in these restrooms that the anti-hero admits that 'this is all so cinematic!' Such self-referential delight could only end with the audience breaking out of the frame, and running towards victory or demise – in either case, rebelling. ⤙*Phaedra Vokali*

Directed by Nikos Panayotopoulos
Scene description: Nikos is off to meet an unknown informant, but is being set up instead
Timecode for scene: 1:30:30 – 1:32:20

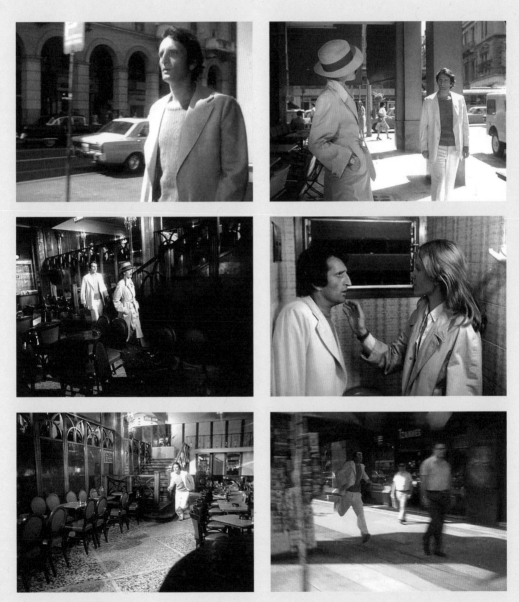

Images © 1974 Yorgos Papalios Ltd.

COVERT ACTION/
SONO STATO UN AGENTE CIA (1978)

LOCATION *Monastiraki Square*

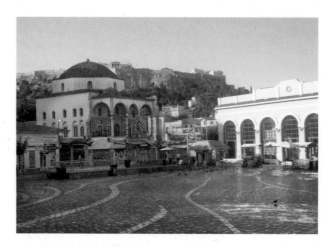

A EURO-SPY ADVENTURE and Greek-Italian production typical of the kind of B-movies which flourished during the 1970s, this film opens with a rather suspicious cargo being transported by tricycle from the Port of Piraeus to the centre of Athens (this almost 'tourist' aspect of the city during the opening credits was a very common phenomenon). The tricycle parks in Monastiraki Square, after having followed a most incoherent route – passing in front of the Panathenaic Stadium, going down Panepistimiou Street, and then crossing through Plaka! The Monastiraki Square scenery creates a sense of illegal activity, combining as it does the traditional with the multiethnic, underground *couleur locale* of the area. The surveillance sequence that ensues persists in the navigational inconsistency witnessed at the beginning of the film, which may not be obvious to a foreign viewer, but an Athenian would be most confused by the circles travelled by the three men (Dimitris Ioakimides, David Janssen and another actor with the most conspicuous overcoat an agent could ever wear), as they walk along alleys of the greater Monastiraki area, from the curiosity shops of Avissynias Square to the Varvakios Market. The scene culminates inside a cinema near Omonia Square, with a hit man (Faedon Georgitsis) acting unhindered and then disappearing into the streets of night-time Athens, even though killer and victim entered the cinema in broad daylight ... Yes, they obviously walked a long way! **↠Elias Fragoulis**

Directed by Romolo Guerrieri
Scene description: Opening scene
Timecode for Scene: 0:04:18 – 0:08:56

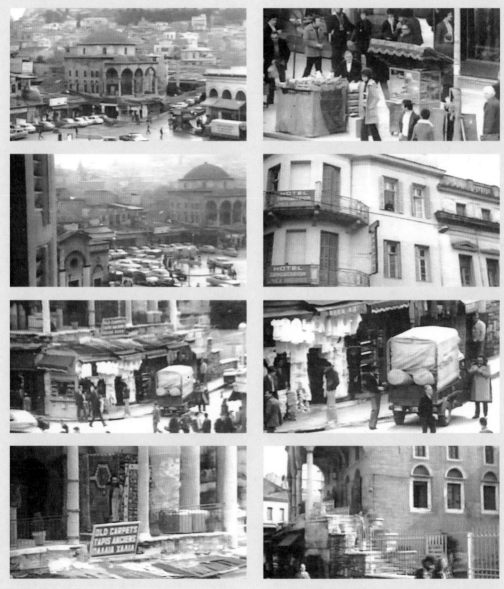

Images © 1978 Staco Film Roma

THE WRETCHES ARE STILL SINGING.../ TA KOURELIA TRAGOUDANE AKOMA... (1979)

LOCATION · *The Chloe open air cinema, 17 Kassaveti Street, Kifissia*

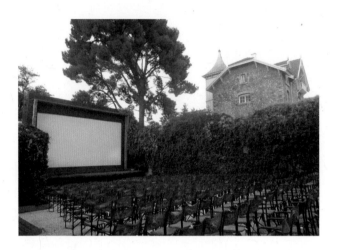

THE WRETCHES ARE STILL SINGING... one of the most unconventional Greek films, looks through the eyes of the 'damned' generation of the 1950s – the part of it that declined riding the wave of the times (the political changeover after the dictatorship) or following the sense of the masses. Four friends (and a fifth who arrives too late), now in their forties, meet again after many years in an isolated house, trying in vain to revive their teenage 'gang'. Dancing through the innocence of their youth and the guilt of their maturity to the sounds of disturbing rock 'n' roll and rain, they prefer to live or die with their ghosts and nightmares, rather than to fit into 'normal' life. Walking a tightrope between love and death and finding the essence in friendship, surrealism and black humour, they reach a dead end. In between murders, sex, alcohol, cigarettes, confessions, dancing, suicides and rides, they romantically wander into an open-air cinema, in daylight, during Christmas! Connie Francis's melodic oldie 'My Heart Has a Mind of Its Own' undescores the scene as a young woman appears, pretending as if she thought there would be a screening, although her real purpose is to meet them. As they all leave together, Del Shannon sings 'Runaway' and the barking of dogs haunts the atmosphere. At the centre of the northern Athenian suburb of Kifissia, the Chloe cinema, a trademark of the Greek summer, as are all open-air movie theatres, as beautiful as ever, still sends off its audience into the streets of the city enveloped in the fragrance of jasmine that dominates its location.
⤞ Efi Papazachariou

Directed by Nikos Nikolaidis
Scene description: The 'gang' visits an open air cinema
Timecode for scene: 1:37:00-1:40:00

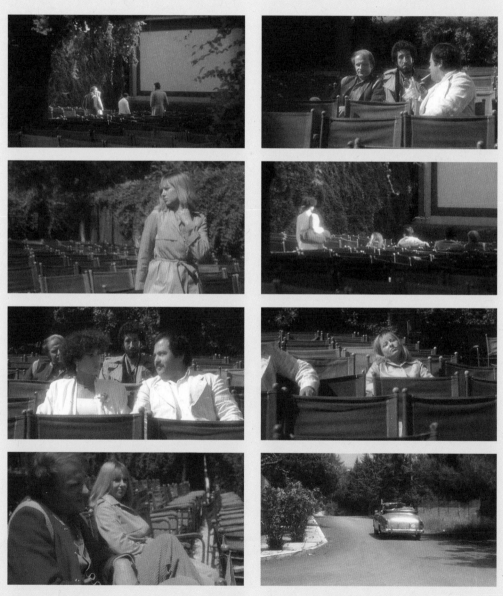

Images © 1979 N. Nikolaidis - M.L. Bloom

ANTHROPOPHAGUS (1980)

LOCATION *Korai Street and Panepistimiou Street, downtown Athens*

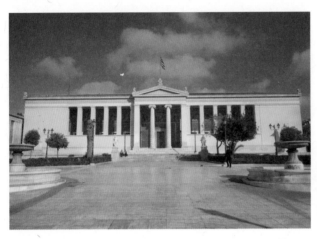

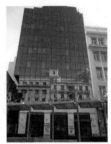

SOMETIME AFTER the decline of Italian splatter exploits and while involved in directing erotic flicks, film-maker Joe D'Amato shot *Anthropophagus*. In this rather irritating low-budget film, a group of tourists arrives on a small Greek island and finds the harbour empty and the inland countryside desolate. As they are eliminated one by one, they come across an old diary revealing that Nikos, who had previously devoured his family, is now coming after them. In the end, Julie, the 'last girl', will confront him in one of the most graphic gore scenes in the history of the genre. However, the most striking feature of *Anthropophagus* is the irrational transformation and geographical restructuring of Athens. The experienced editor Ornella Micheli links places of the city which in no other case could be tied together, i.e. the terminal of the Mont Parnes cable car appears on Dionysiou Areopagitou Street, opposite the Herod Atticus theatre. There, the tourists meet their friend, Andy, who has crossed the centre of Athens, from the Polytechnic School to the Academy, on to Panepistimiou Street and down Korai Street, in a Volkswagen mini-van. In a long-shot, the camera follows Andy as he crosses Korai Street, now a pedestrian way and where since 2000 the Athens Metro Panepistimio Station has been located, heading towards Klafthmonos Square on Stadiou Street. On the left side of Korai Street, among the storefronts, one can discern the basement cinema Asty. Characterized today as an 'important historical and cultural landmark', it was built in the mid-1930s and partially used as a Nazi torture chamber during World War II. **◆◆ *Ursula-Helen Kassaveti***

Directed by Joe D'Amato

Scene description: Andy, a tourist, is driving in downtown Athens on his way to meet his friends
Timecode for scene: 0:06:35 – 0:10:03

Images © 1980 Filmirage & P.C.M. International

VOYAGE TO CYTHERA/TAXIDI STA KYTHIRA (1984)

Hadrian's Arch

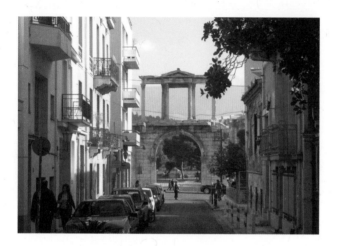

THE ALLEGORY, according to Walter Benjamin, is the act through which the 'writing of the signs of the past' is awakened. This resurrection occurs in *Voyage to Cythera*'s opening sequence. The silhouette of a young boy emerges slowly from a dark room. Outside, one can hear German soldiers marching. In the torpor of the afternoon, the child begins walking. He takes the deserted streets of Athens's oldest quarter and reaches Hadrian's Arch. Suddenly, the silhouette of a German soldier appears, standing guard. The child approaches cautiously and, with a quick movement, makes the soldier's truncheon fall, then runs away. One of Angelopoulos's childhood memories becomes that of the film's hero. And the memory of the Greek people is also, in a minor key, engraved in the child's gesture. Indeed, on 31 May 1941, one month after the Germans entered Athens, two communist students tore down the swastika that hung on the Acropolis. The short circuit caused by the fleeting confrontation between the soldier and the child beneath Hadrian's Arch awakens another latent image of the past; that is, an image emerging from the time when 'the old city of Theseus' ended here. While the soldier does not seem to be guarding any visible frontier, the child's gesture reveals the only line of demarcation that matters: the line that separates Modern Athens from its history. The temporal 'circuit' establishes, in this way, a paradoxical time where the layers of the past meet in an incredible shortcut. Angelopoulos consecrated his entire filmography to this awakening of our gaze.
➻**Sylvie Rollet**

Directed by Theo Angelopoulos
Scene description: A German soldier is chasing a young boy in Plaka
Timecode for scene: 0:01:30 – 0:04:28

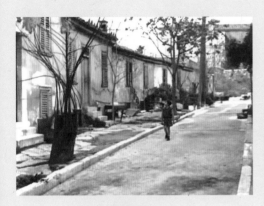

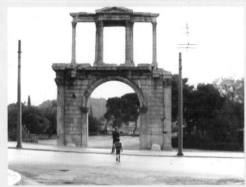

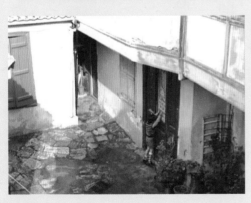 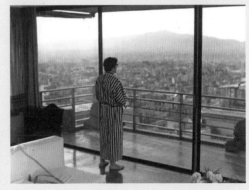

CONTROVERSIES OF SPACE IN POPULAR GREEK CINEMA (1950–1970)

Text by
ANGELIKI
MILONAKI

From the Courtyard to the Living Room

GREEK POPULAR CINEMA of the 1950s and the 1960s played a prominent role in the development of filmic representations of Athens. This is better understood if one takes into account the rebuilding of domestic film production and the proliferation of the city's images on-screen after World War II and the Greek Civil War which coincided with the urban reconstruction of Athens, along with its rapid transformation into a modern capital. For more than twenty years, the interaction between Greek cinema and urban development generated a multitude of Athenian screenscapes in over 2,000 feature films.

The first post-war feature films that centred on Athens can be found amid the work of the film-makers of the 'Athenian School', a term subsequently coined by Greek film critic Aglaia Mitropoulou to define a group of acclaimed directors of the 1950s, such as Yorgos Tzavellas, Dinos Dimopoulos, Alekos Sakellarios and Nikos Tsiforos, who shared an interest in the city. They situated their stories in the bustling and vibrant historical centre of Athens, focusing on the neighbourhoods around the Acropolis

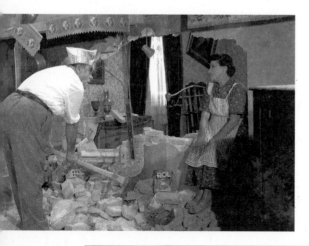

which represented aspects of social bonding and community – for example, the old neighbourhood of Plaka, which was a symbol of this way of life. They used the readily available urban settings of Athens to turn the city into the real protagonist of these films. Their aim was to achieve an air of realism and authenticity and, at the same time, to familiarize cinema audiences, in their majority internal migrants of the lower classes, with the realities and challenges of city life.

Although the film-makers of the 'Athenian School' developed a variety of styles, they all promoted a 'public view' of the city, filming landmarks of the old Athens – the Acropolis, the Parthenon, Lycabettus Hill, Hadrian's Arch, the Ancient Agora, Monastiraki Square and, predominantly, the neighbourhood of Plaka. Plaka, vividly depicted as a self-sufficient 'urban village' with two-storey traditional houses, flowering courtyards and stone paved streets, is the most frequently filmed location.

Athens's leading role in these films was painstakingly illustrated in Michael Cacoyannis's romantic comedy *Kyriakatiko xypnima/Windfall in Athens* (1954), which best exemplified this 'public view' through an idyllic portrait of old Athens, comprising panoramic introductory shots of picturesque scenes of Plaka. Along with films which shared the same view, such as *O methystakas/The Drunkard* (Yorgos Tzavellas, 1950), *I kalpiki lira/The Counterfeit Coin* (Yorgos Tzavellas, 1955), *To amaxaki/The Little Carriage* (Dinos Dimopoulos, 1957) and *I kafetzou/The Fortune Teller* (Alekos Sakellarios, 1956), *Windfall in Athens* established a strong link between Greek cinema and the city.

Similarly, yet with different aesthetic strategies, Greek film-makers of a neo-realist trend, for example Nikos Koundouros and Grigoris Grigoriou, were also committed to a 'public view' of Athens, yet in a more controversial way. They

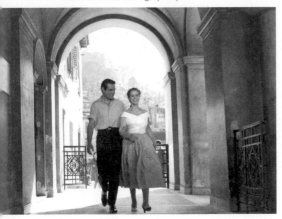

Above © 1957 Finos Film
Opposite © 1959 Finos Film

also shot on location, but they employed a neo-realistic *mise-en-scène* to chronicle the struggle for survival of the oppressed working-class population living in the neglected neighbourhoods of Athens.

One of the most acknowledged neo-realist Greek films of the 1950s, *Magiki polis/Magic City* (Nikos Koundouros, 1954), recorded the living conditions of the working class in Athens, providing a dystopian view of the city's margins. This negative aspect of Athens gradually became a trend not only in neo-realist films, such as *O drakos/The Ogre of Athens* (Nikos Koundouros, 1956), but also in noir films, including *Englima sta paraskinia/Murder Backstage* (Dinos Katsouridis, 1960), *I adistakti/The Ruthless* (Dinos Katsouridis, 1966) and *Listia stin Athina/Robbery in Athens* (Vangelis Serdaris, 1969).

The 1960s witnessed an unprecedented boom in Greek film production, which, although rich in genre diversity, was surprisingly poor in the quality of the depiction of the city. Confronted with the changing urban realities and pressured by producers – especially Finos Film, the leading production company – looking for films of mass entertainment, film-makers no longer sought out authentic depictions of the city's neighbourhoods. Rather, they restricted themselves to conventionalized *mise-en-scène* in studio-made settings. Athens became a recognizable but ordinary background, usually appearing in introductory scenes,

The 1960s witnessed an unprecedented boom in Greek film production, which, although rich in genre diversity, was surprisingly poor in the quality of the depiction of the city.

in order to familiarize cinema audiences with the advantages of urbanization which were celebrated in the image of the modern apartment. This noticeable turn from a public to a more privatized vision of Athens was mainly articulated through studio-made film-hits of the 1960s, which abandoned location shooting and zoomed in on the enclosed space of the living room.

Popular film comedies of the 1960s, such as *Gamos ala… Ellinika/Marriage… Greek Style* (Vassilis Georgiadis, 1964) and *Teddy boy, agapi mou/Teddy Boy, My Love* (Yannis Dalianidis, 1966), explored the 'dream of a modern apartment' – a profound desire of their characters. The private spaces of the apartment – which symbolically converge in the most frequently depicted family space: the living room – are crammed with stylish furniture and decorative elements, and draw on new sociocultural values imported from the West. In this context, films promoted the qualities of an imported cultural space, which symbolized the American way of life, while negotiating the advantages and the disadvantages of the modern apartment. Thus, Greek film production represented the intense spatial antagonisms between the public and the private sphere, between 'courtyard' and 'living room' cultures. Even films which continued to insist on a nostalgic vision of Athens, such as *I gyni na fovite ton andra/The Wife Shall Fear the Husband* (Yorgos Tzavellas, 1965), were compelled to finally incorporate themselves into the new trend of reconstruction and modernization.

Concurrently, there was an alternative yet influential cinematic depiction of Athens, present primarily in the popular film musicals of the 1960s, which advocated a touristic view of the city. In many musicals, such as *Rendez-vous ston aera/Rendez-vous in the Air* (Yannis Dalianidis, 1966, *I thalassies i handres/The Blue Beads from Greece* (Yannis Dalianidis, 1967) and *Marijuana… Stop!* (Yannis Dalianidis, 1970), Athens was merely the backdrop for a spectacle, with no particular narrative strength of its own. However, despite the interest shown by musicals in a different aspect of the city, there were very few characteristics of the 'real' Athens in the films of the 'private view'. Greek popular cinema of the 1960s failed to face the complexities and challenges of urban life, as it was exclusively devoted to promoting an idealized view of Athens, restricted to the symbolism of the apartment and the ideals of 'living room' culture. ✢

maps are only to be taken as approximates

CHAIDARI

EGALEO

KORIDALLOS

NIKAIA

AGIOS
IOANNIS
RENTIS

KALLITHEA

MOSCHATO

PIREAS

ATHENS LOCATIONS
SCENES 25-32

ARPA-COLLA (1982)

LOCATION *Rex Cinema, 48 Panespistimiou Street, The Hall of the 7th art, 96-100 Acadimias Street and Kanningos Square*

ARPA-COLLA is a satirical comedy, written and directed by Nikos Perakis, that pokes fun at the Greek movie industry of the 1980s. In modern Greek, *arpa-colla* means doing something in a haphazard, slipshod way, sometimes in order to make a fast buck – as is often the case in the film business. On their way to potential investors, two young directors stroll past the historic Rex Cinema on Panepistimiou Street near Omonia Square. Built in the mid-1930s, it was designed by Vassilios Kassandras and Leonidas Bonis as a multi-purpose entertainment venue and featured many art deco elements. Some of Greece's greatest theatrical productions were staged here. The ground floor later became a nightclub, while upstairs the Kotopouli Theatre was the largest theatre in Athens. Today, it is home to one of the National Theatre's stages. The basement, originally intended as a ballroom, housed the Cineak Theatre, which showed newsreels and children's films.Eventually, the two film-makers reach the so-called Hall of the 7th Art on the corner of Acadimias Street and Kanningos Square. Designed during the 1950s by Yannis K. Lygizos, for many years it housed major production and distribution companies. Bar Hollywood, on the ground floor, was a regular hangout for the film crowd, but as a result of the crisis in Greek cinema the building changed owners and the bar lost its initial glamour. It is now a private college, the bar changed its name to Asty, and the famous 20th Century Fox logo that towered above it was replaced by a sculpture by George Houliaras. **➜ Despina Mouzaki**

Directed by Nikos Perakis
Scene description: Two film-makers wander around Athens in search of inspiration and investors
Timecode for scene: 0:33:03 – 0:36:06

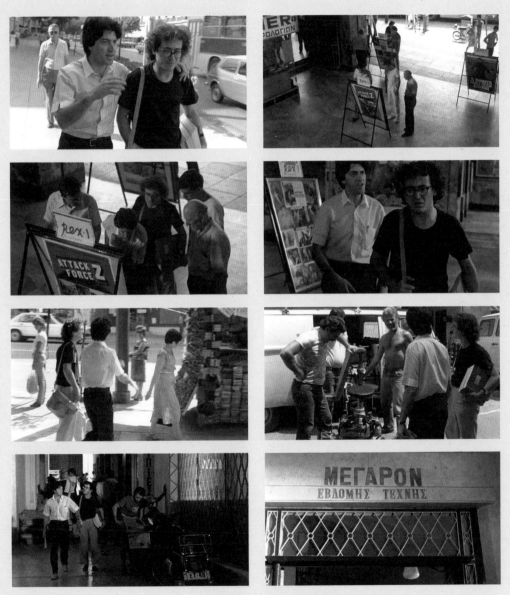

Images © 1982 G. Panoussopoulos Ltd, Greek Film Center, Spentzos Films, Taurus Film

MANIA (1985)

National Garden

BRINGING A HINT of the archaic and the animalistic of the Dionysian and primitive into the life of a modern metropolis, George Panoussopoulos's *Mania* transforms a garden into an urban jungle where the beast of libido and absolute freedom gets to run wild. Its heroine, Zoe, a thoroughly modern woman, leaves the bustling Athens streets and steps into the National Garden. Myth and primal urges, the thick foliage, the play of light and shadow, and the mystical essence of a hot summer day turn a timid woman into a creature of bygone times, a maenad and a nymph. And her awakening spreads like a virus, freeing everyone from their composed selves. Starting with the kids visiting the duck pond, clean-cut boy scouts and proper little girls run amok, following her lead. Panoussopoulos makes great use of an Athenian landmark, transforming the garden commissioned by Queen Amalia in 1838 and designed by the German agronomist Frederick Schmidt, into an alien, bewitching landscape. Not that it was hard to do. Visiting the park on any given day, you are bound to leave your normal self behind. Wandering along its pathways, getting lost in its alleys, surrounded by orgiastic nature, chirping birds and the odd ancient ruin, it's not hard to feel that time has stopped, that the rules of society don't apply, and that the rustling in the bush behind you isn't just a cat, but the hoofed legs of the god Pan, in a state of wonderful mania, preparing to seduce you too.
⊷ Yorgos Krassakopoulos

Directed by George Panoussopoulos
Scene description: Zoe wanders around the duck pond and sets off the kids' wild play
Timecode for scene: 0:47:16 – 0:50:10

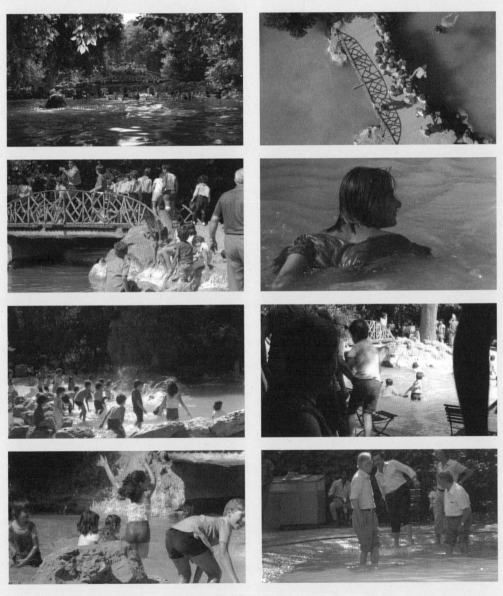

QUIET DAYS IN AUGUST/
ISIHES MERES TOU AVGOUSTOU (1991)

LOCATION *104 Agiou Meletiou & Kampani Streets, Patissia*

FILMING A DESERTED ATHENS in August, Voulgaris depicts loneliness, nostalgia, the need for human contact and unfulfilled love. In this scene, Aleka (Aleka Paizi), an old woman living by herself, decides to make the first move towards getting acquainted with her neighbour, whom she has been observing lately while at the same time aware of being observed by her. This neighbour, a mysterious younger woman (Themis Bazaka), besides being Aleka's mirror image, will become an intermediary between life, love and death, leading the older woman to a sweet end. In *Quiet Days in August*, the element of voyeurism is at the fore throughout the script, the camera movement and the use of voice-over emphasizing the interpenetration of private and public spaces. This interpenetration outlines the friendly ambience, the affinity and the closeness of people's lives in old Athenian neighbourhoods, with their palatial blocks of flats and the pedestrian roads with their fruit trees. This particular neighbourhood is located in the area of Patissia, one of the most archetypical Athenian districts which was an original urban landscape of good repute at the climax of the expansion of post-war Athens. Nowadays, inhabited to a great extent by refugees, this part of Patissia is considered one of the most densely built and decadent sections of the city, while it has also been stigmatized by cases of racist violence and excesses in the nearby neighbourhood of Agios Panteleimonas. This particular neighbourhood, however, in spite of the rise of the far-right movement in Greece, continues to be inhabited by refugees and Greeks living in harmony, and is characterized by a multicultural and extrovert ambience. **⇢Myrto Kalofolia**

Directed by Pantelis Voulgaris
Scene description: Aleka visits her neighbour
Timecode for scene: 0:50:37 – 0:52:53

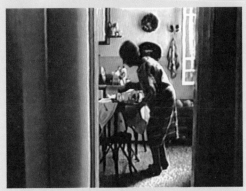

Images © 1991 Greek Film Centre, Kineton

FROM THE EDGE OF THE CITY/ APO TIN AKRI TIS POLIS (1998)

LOCATION *Omonia Square*

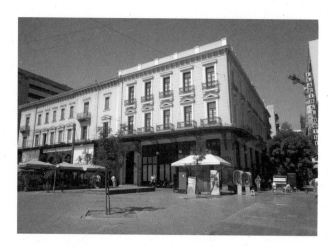

FROM THE EDGE OF THE CITY is rightly considered a seminal film in the history of Greek cinema. It could be described as an ethnographic meta-fiction that explores the post-Soviet transformation of Athens's demographic make-up and the new spatial economies that emerged as a result. Giannaris's subject is Sacha (Stathis Papadopoulos) and his friends – a group of russophone teenage boys from Kazakhstan drifting across Athens, trying to escape their bleak immigrant neighbourhood on the city's fringe. In the early 1990s, modifications in Greek immigration law enabled tens of thousands of Russians and Eastern Europeans to request citizenship on the grounds of Greek ethnic heritage. The amateur actors who appear in the film came from this demographic. Giannaris met them in some of the same locations where he shot the film and observed them engaging in some of the same activities and conversations he depicts. We follow the teenagers breaking into cars, doing drugs, clubbing, going to a brothel, trying their hand at pimping immigrant women or each other, and cruising for Johns. Omonia Square in central Athens is where the boys go to turn tricks. Omonia has historically been a space where newcomers to Athens converged, as it has always been a transportation, entertainment and hospitality hub, offering a broad range of diversions, from adult movie-houses and massage parlours to hotels, department stores, theatres, coffeehouses and restaurants. One of the surviving hotels, Hotel Helikon, is incorporated in the Omonia scene. Failed urban planning policies and Greece's becoming a port-of-entry to EU countries turned the drug-dealing and prostitution that were always present in Omonia into the dominant economic activity, as the once-diverse ethnic and class make-up of the square's denizens narrowed to lumpen immigrants. **➻ Vassiliki Tsitsopoulou**

Directed by Constantine Giannaris
Scene description: The boys are hustling in Omonia Square
Timecode for scene: 0:13:06 – 0:15:40

THE ATTACK OF THE GIANT MOUSSAKA/
I EPITHESI TOU GIGANTIEOU MOUSSAKA (1999)

LOCATION > *Ermou Street, Kapnikarea Church*

A GIANT MOUSSAKA, the result of an extraterrestrial accident, attacks
the city of Athens, threatening to obliterate centuries of civilization. It
is juicy, full of carbohydrates and made of all the tender, wholesome and
destructive ingredients that can be found in any Greek household. Panos
H. Koutras made his version of the American B-movie thriller for 1999 just
as Greek society was anxiously staring into the twenty-first century. The
'TV cameras of 2000' document horrific scenes in downtown Athens. The
flying moussaka makes its way to the city centre; it passes by the statue of
the Greek revolutionary hero Kolokotronis, who seems to be showing it the
way, pointing straight ahead, towards Ermou Street. Just two years after it
was made into a pedestrian street and paved with stone, central Athens's
busiest commercial street is transformed into a battlefield. Athenians who,
under normal circumstances, would have been shopping in a happy daze
fall prey to the home-cooked behemoth's calories. The camera swoops by
Stratigiou's clothing store, only recently in the news for having been sold to
a multinational conglomerate for 1 billion drachmas. At the centre of a small
square, the time-worn Byzantine church of Kapnikarea, built in the eleventh
century, is open to all kinds of urbanites wishing to pray for salvation from
modern life's multiple woes. 'After a terrible night, the sun rises again over
our ravaged city,' Panos H. Koutras and Panayotis Evangelidis say in the film's
screenplay. A cinematic mantra of goodwill on a loop, playing perpetually, to
this day. **⇢Leda Galanou**

Directed by Panos H. Koutras
Scene description: A giant moussaka attacks the city centre of Athens
Timecode for scene: 0:49:37 – 0:50:57

CHEAP SMOKES/FTINA TSIGARA (2000)

LOCATION *Arsaki Arcade, Panepistimiou Street*

IN *CHEAP SMOKES*, the protagonist wanders through the streets of deserted, nocturnal Athens in August. This romantic comedy is a pastiche of moments in a city that acts as the driving force for philosophical quests. 'I'm producing an artwork,' he says, 'I'm wandering through the city.' In the company of a young unknown woman, he strolls down Panepistimiou Street, a main artery of the commercial and historical city centre. Their walk is interrupted by monologues delivered by various characters which focus on the meaning of life, the secret parts of the city and love. When they enter the Arsaki Arcade, they are no longer interrupted, as they momentarily abandon the city and its stories. There are numerous arcades in the city centre, acting as a beehive of commercial activities. Only a few of them share the same architectural characteristics with their European counterparts. These are the ones built at the beginning of the twentieth century and located between Panepistimiou and Stadiou Streets. The Arsaki Arcade, like the nearby arcades, has a glass roof, a meticulously designed marble floor and homogeneous shops; these constitute the three main characteristics of Walter Benjamin's arcades. Contrary to the less luxurious arcades away from Panepistimiou Street that are still highly populated, the Arsaki Arcade is today as deserted in the morning as it is during an August night. Stripped of the glamour of previous decades, lined with closed-down shops and decorative Greek flags, it seems to be awaiting the much-discussed, controversial pedestrianization of Panepistimiou Street while at the same time representing, in a state of limbo, the hope for a different future. ➴***Katerina Polychroniadi***

Directed by Renos Haralambidis
Scene description: A young man and a young woman flirt
with each other while wandering through nocturnal Athens
Timecode for scene: 0:24:08 – 0: 25:31

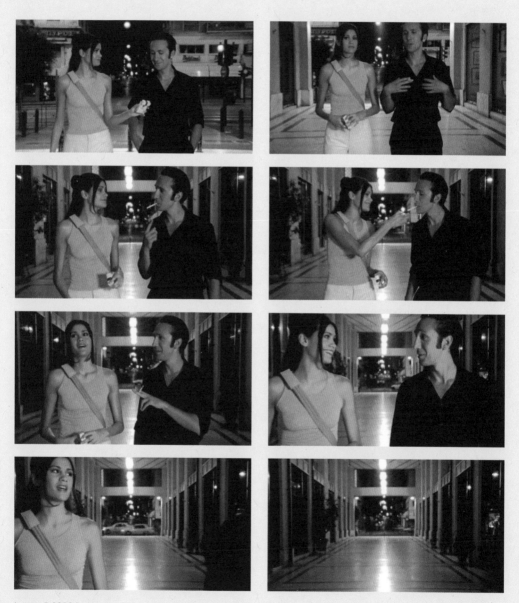

SIGNS AND WONDERS (2000)

Kallirois and Dimitrakopoulou Streets, Koukaki

ATHENS HAS MANY FACES, yet the one chosen by Jonathan Nossiter in *Signs and Wonders* is a crude one. Cast in concrete and filled with noise, the city serves as a background for a psychological thriller in which three stories unfold: the struggle of a lost man trying to make sense of a fragmented life; the break-up of a couple shaken by adultery; and the revival of history incarnated in the confrontation between two men. Alec Fenton (Stellan Skarsgård) is an American expatriate businessman and father of two children, comfortably settled in Athens. After wavering between his wife Marjorie (Charlotte Rampling) and his mistress Katherine (Deborah Kara Unger), he finally realizes he wants to save his marriage. When he finds out that his – by then former – wife has entered in a relationship with Greek journalist Andreas (Dimitris Katalifos), he rushes over to his apartment determined to challenge him. In a dilapidated penthouse veranda that overlooks Athens, a strange face-to-face occurs, in which the characters are more than what they seem to be. Alec, the American businessman, pretentious and demanding, refers to destiny. Andreas, the Greek leftist political activist, though apparently detached, cannot hide a grudge he holds against Americans, whom he considers accountable for the military dictatorship that arrested and tortured him. Subjective trajectories meet collective history and modern geopolitics, but the final protagonists are not the ones initially imagined. As for the bright Athenian light, it isn't enough to attenuate the oppressive atmosphere created by Nossiter. And, in retrospect, the veranda's broken railing appears almost as a sign of the country's decay and imminent collapse. **•◆ Angeliki Koukoutsaki-Monnier**

Directed by Jonathan Nossiter
Scene description: Alec visits Andreas, his ex-wife's lover
Timecode for scene: 0:42:47 - 0:47:10

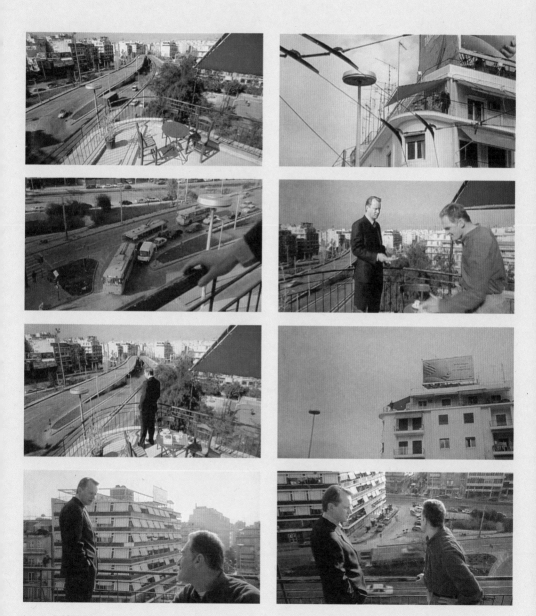

Images © 2000 Goatworks Films, Ideefixe Productions, Industry Entertainment, MK2 Productions, Sunshine Amalgamedia

A TALKING PICTURE/UM FILME FALADO (2003)

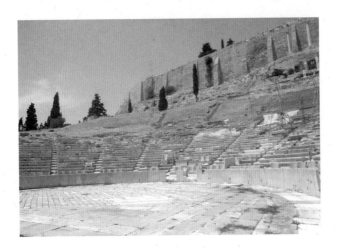

SAILING THE TREACHEROUS WATERS of history, a mother takes her daughter on a cruise, hoping to eventually join her aviator husband in Bombay. Exploring various female identities as they idle across the Mediterranean, Rosa Maria (Leonor Silveira), a brilliant storyteller, guides 7-year-old Maria Joana (Filipa de Almedia) through a veritable minefield of ancient and contemporary history, shielding her from nothing and openly explaining everything. Both elegantly simple and deeply intellectual, Manoel de Oliveira's feature takes nothing for granted. Catherine Deneuve, Stefania Sandrelli and Irene Papas board the ship as a French businesswoman, a former Italian model and a Greek stage queen – three goddesses floating on a bottomless ocean of history. But long before the film deceptively turns into an intimate dinner party, it pays tribute to some of the greatest landmarks in western civilization: Pompei, the Pyramids, Hagia Sophia and the Parthenon. Nothing out of the ordinary, except the real treasure doesn't stand on top of the Acropolis; it lies at its foot. It's the Theatre of Dionysus, whose weathered beauty might have been overlooked if it weren't for an art-loving priest. Drawing Rosa Maria's attention away from the irreverent Parthenon, he speaks of a beauty more humble but ever so deep, almost devoured by the ground beneath their feet. The ruins of the Theatre of Dionysus are much more palpable than the vanished statue of the goddess Athena, but both are directly opposed to his religious beliefs. *A Talking Picture* might be full of surprises, but nothing feels quite as unexpected as the sight of a priest crossing himself in the shadow of the Twelve Olympians. At least not if you're Greek.•❖*Despina Pavlaki*

Directed by Manoel de Oliveira

Scene description: Rosa Maria and Maria Joana are introduced to the Theatre of Dionysus by a Greek Orthodox priest

Timecode for scene: 0:24:07 – 0:27:26

DIRTOPIA AND ITS URBAN SUBCULTURES

Text by
AFRODITI
NIKOLAIDOU
AND ANNA
POUPOU

Cinematic Athens in the Post-dictatorship Era

AT THE END OF THE 1960S, after three decades of celebration of post-war Athenian modernity by Greek and international films, the dream of a cosmopolitan capital turned into a parochial nightmare. With the fall of the military junta in 1974 and the restoration of a democratic regime, the inhabitants of the capital began to realize that explosive construction and lack of planning had transformed Athens into a city with serious functional and ecological problems, a total absence of basic infrastructure and a lack of aesthetics in terms of the built environment. In 23 April 1979, an article in *Time* magazine entitled 'A city is dying' described the Athenian scenery in apocalyptic terms: overpopulation, traffic, noise, lack of sewage and sanitation facilities, smog and pollution at dangerous levels. This negative public discourse culminated in the 1980s during the socialist government of Panhellenic Socialist Movement (PASOK), which based its rhetoric on the development of the provinces and decentralization. Thus, in the 1980s, Athens appeared in media and film as a monstrous megalopolis, a chaotic organism which had grown disproportionately at the expense of the periphery.

Realist cinema of the 1970s had already shown this shift in the urban discourse. In *To proxenio tis Annas/Anna's Matchmaking* (Pantelis Voulgaris, 1974), Athens is depicted as a place of exile for the provincial characters who dream of returning to their native village. In *To vary... peponi/The Heavy Melon* (Pavlos Tassios, 1977), the tiny apartments where the characters live seem like prisons to the newcomers, while the promised land of the capital has betrayed their hopes. Vassilis Vafeas's *Repo/Day Off* (1982) presented the irrationality of everyday life in a city walking the fine line between unattained modernist standards and surviving traditional mentalities. In the film *I apenandi/A Foolish Love* (George Panoussopoulos, 1981), the yellow layers of air pollution are visible on the screen, transforming the Athenian landscape into a dystopian, contaminated urban sprawl. But these were exceptions. The majority of the radical, highbrow auteurs of New Greek Cinema tackling subjects of recent political history avoided Athens and preferred to explore the peripheral region of villages or small towns, most of the times in a nostalgic, romanticizing way. Thus, they relegated Athenian themes and scenery to inexpensive, B-series productions; teenage, sex or absurd underground comedies; and crime and social problem films. Later in the decade, these sub-genres flourished as video provided even cheaper productions and led to the so-called 'videotape era'.

The 1980s was, therefore, a period during which film and video directors documented the problematic city in often low-budget, makeshift productions. In the opening sequences, Athens was no longer signalled by its ancient monuments or its emblematic 1960s buildings. The new markers of the city as they recur in the establishing sequences were a skyline dense with TV antennas; packed bus stops; the noise of traffic jams; the heavily congested city streets and peripheral motorways; claustrophobic, dark apartments in the narrow streets of working-class districts;

unswept, deserted streets on hot summer days; notorious cafeterias and discotheques lining anonymous Athenian squares. And, somewhere in the background, the Parthenon emerging through the thick, grey, poisonous smog.

In this deteriorating landscape, urban youth subcultures seemed to flourish and gain a special place on-screen: junkies in *Ta vaporakia/The Pushers* (Pavlos Tassios, 1983) and *Ta tsakalia/The Jackals* (Yannis Dalianidis, 1983); rockers and post-hippies wandering in the district of Exarhia, Nea Smyrni Square and other unrecognizable petit-bourgeois locations in *Souvliste tous!/Barbecue Them!* (Nikos Zervos, 1981) and *Knock Out* (Pavlos Tassios, 1985); football hooligans congregating in and outside Karaiskaki Stadium in Neo Faliro in *Thyra 7/Gate 7* (Nikos Foskolos, 1983) and *Hooligans* (Kostas Karagiannis, 1983); pseudo-punks, break-dancers and disco-lovers dancing and drinking at Athenian discotheques: 'Jackie-O' in *I epikyndini (mia diamartiria)/The Dangerous* (Yannis Dalianidis, 1983), 'Aftokinisi' in *Delirio/Bitter Movie* (Nikos Zervos, 1983), and 'Dorian Gray' in *Roz gatos/Pink Cat* (Yannis Hartomatzidis, 1985). Motorcycle riders, the so-called kamikaze, invaded cinematic Athens and its avenues, namely Vouliagmenis and Syngrou, in *Vengos, o trelos kamikazi/Vengos, the Crazy Kamikaze*

Athens was no longer signalled by its ancient monuments or its emblematic 1960s buildings. The new markers of the city …were a skyline dense with TV antennas; packed bus stops; the noise of traffic jams.

(Dinos Katsouridis, 1980), *Kamikazi agapi mou/Kamikaze My Love* (Yannis Dalianidis, 1983), and even the arthouse film *A Foolish Love*. However, these subcultures connoting the vices and sins of the city adhered mostly to signifiers of style and not so much of social context.

Among the various urban heroes of these subcultures, Jimmy Panoussis, a satiric singer and stand-up comedian, and Nikolas Asimos, an underground musician and singer known for his seditious lyrics and subversive street happenings in Exarhia, became icons of an alternative way of looking at things, stemming from the deteriorating city and going against the monumental space imposed by the elitist culture. They both appear in the absurdist comedy *O drakoulas ton Exarhion/The Dracula of Exarchia* (Nikos Zervos, 1983). In another Zervos film, *Exoristos stin kendriki leoforo/Exile on Main Avenue* (1979), the characters drink and kiss in a weird performance in front of the monuments of the Library, the University and the Academy, flouting this sacred Athenian Triptych. Yorgos Poulikakos, the leader of the prominent rock band Exadaktylos who, during the junta, sang his urban lyrics against a conventional way of life, is the protagonist of the film *Barbecue Them!* In the opening sequence, three misfits walk upon Filopappos and Lycabettus Hills, admiring the smoggy city view rather than the Acropolis, while Poulikakos's distinctive voice echoes ironically: 'Another day begins in our beautiful city.'

These films and heroes were criticizing and rejecting the post-junta way of urban life, while at the same time enjoying the cultural and political euphoria of the 1980s. However, their nihilistic and defeatist point of view charted individual trajectories that would lead Athens to similar dead ends. During the 1990s, despite the change in the urban discourse, these negative representations can still be traced in low-budget disaster and horror films, as well as in arthouse films. These few, marginal images belied the false optimism of the period before the 2004 Olympic Games, showing the monstrous capital now threatened by an actual monster in *I epithesi tou gigantieou moussaka/The Attack of the Giant Moussaka* (Panos H. Koutras, 1999) and zombies who returned from antiquity in *To kako/Evil* (Yorgos Noussias, 2004), or depicting the city as a dark dystopia in *O hamenos ta perni ola/Loser Takes All* (Nikos Nikolaidis, 2002) and *Delivery* (Nikos Panayotopoulos, 2004). Years later, Athens still is a beloved dirtopia. ✤

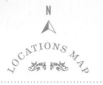

maps are only to be taken as approximates

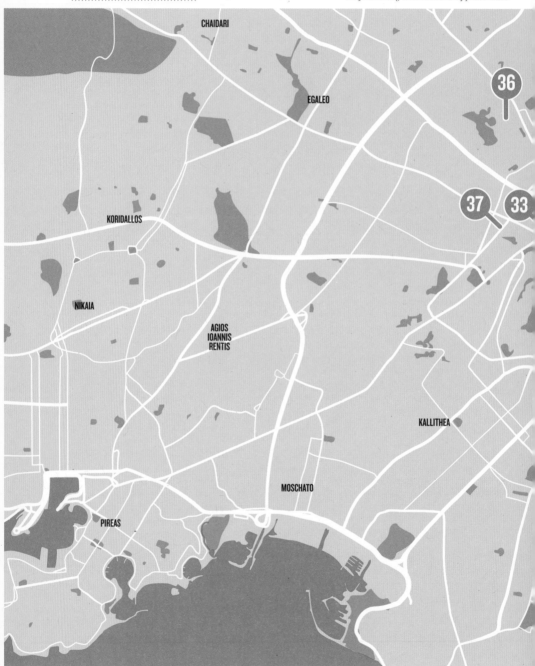

CHAIDARI

EGALEO

36

KORIDALLOS

37 33

NIKAIA

AGIOS
IOANNIS
RENTIS

KALLITHEA

MOSCHATO

PIREAS

ATHENS LOCATIONS
SCENES 33-39

A DOG'S DREAM/TO ONIRO TOU SKYLOU (2005)

LOCATION *Bios bar, 84 Pireos Street*

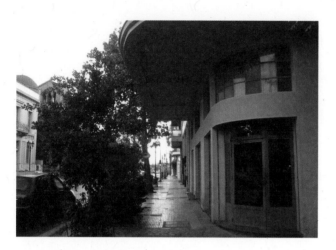

THE CITY'S MAGICAL SIDE is revealed by director Angelos Frantzis, who exploits cinematographically the labyrinthine urban setting and foregrounds the unorthodox architecture of the centre of Athens. Through the continuous, overwhelming and subjective gaze of the camera, Frantzis transmutes a real setting into a fantastic one. For one night, the centre of Athens is transformed into a fantasy *maquette*, the stage for a dream and four interwoven stories in which the heroes and their alter egos are involved in a parallel pursuit as they follow the signs of their destiny. At dawn, this multiple pursuit ends at a border. Just as the dawn is the grey zone between day and night, so does the Bios bar (on Pireos Street, just across from the ancient cemetery of Keramikos), where the final scene takes place, constitute a border between the commercial centre of Athens and the former industrial zone that used to extend beyond Pireos Street. It is the grey zone between nightlife and conventional day life; fairy tale and truth; dream and reality. Apart from the cinematographic, symbolic limit between mainstream and alternative life, the Bios bar constitutes the real symbol of a contemporary, transformed Athens. As one of the first cultural centres promoting an alternative trend in urban culture, it represents the development of the entire neighbouring areas of Gazi and Metaxourgio, areas that used to be the decadent, hardcore industrial zone of Athens. However, during the last fifteen years, deserted industrial buildings as well as the old gas factory – now called Technopolis – are used as cultural and entertainment centres, presenting indeed, like Frantzis's film, a magical side of Athens. **⇥Myrto Kalofolia**

Directed by Angelos Frantzis
Scene description: The protagonists cross paths at the Bios bar
Timecode for scene: 1:19:35 – 1:23:50

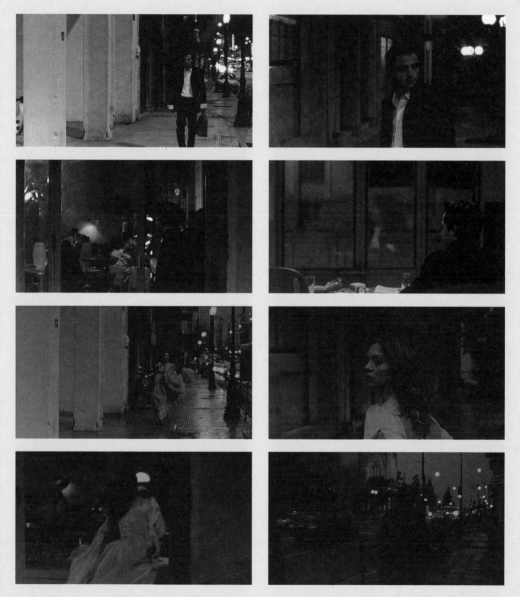

CORRECTION/DIORTHOSI (2007)

LOCATION
Alexandras Avenue, Panathinaikos (or Apostolos Nikolaidis) Stadium

INSPIRED BY AN ACTUAL EVENT, Anastopoulos's film is about a Greek hooligan who murders an Albanian fan after a football match between the two national teams. Released after serving a four-year sentence, Yorgos (Yorgos Symeonidis) roams the streets, goes to a rehabilitation centre and sleeps in a city square with other homeless people. From day one, he searches for the family of his victim. Stalking the daughter (Savina Alimani), he finds the kebab shop where her mother (Ornela Kapetani) works. Always silent, Yorgos breaks ties with the nationalist gang he belonged to and endeavours to approach the family without being sure whether he wants to be punished or forgiven. The very last scene of the film begins with a close-up of the mother standing in front of a window in her house. Panning slowly on the road between the house and the football stadium, the camera stops for a second on the daughter who has come home from school, and then continues showing the stadium full of graffiti. On the pavement outside the stadium, Yorgos walks slowly along Alexandras Avenue. The camera follows him for a while and then rises to a panoramic view of the street traffic and the Court of Appeals. The music, introduced for the first time in this scene, stops and the siren of a police car dominates the end of the film. Yorgos, who has so far been depicted behind bars, either in prison or outside the school, now vanishes in the ambivalent open space of the city. ✦*Manolis Arkolakis*

Directed by Thanos Anastopoulos

Scene description: Yorgos leaves the house of his victim's family

Timecode for scene: 1:20:55 – 1:22:20

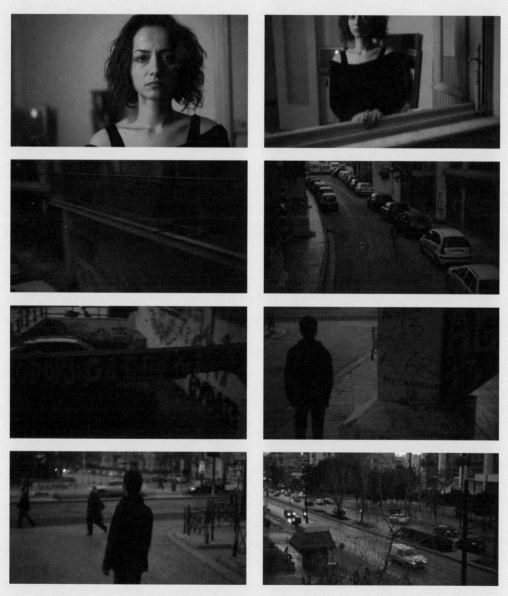

MY LIFE IN RUINS (2009)

LOCATION *The temple of Hephaestus, the Ancient Agora*

MY LIFE IN RUINS was Nia Vardalos's attempt to repeat the enormous commercial success of *My Big Fat Greek Wedding* (Joel Zwick, 2002) by returning to a Greek-themed comedy. She stars as Georgia, an academic-turned-tour guide in today's Athens, who tries desperately to make her international group of unsophisticated tourists love Ancient Greece as much as she does, but to no avail. On the surface, the plot leads her to regain her 'mojo' – her passion or *kefi*, as the script translates it in Greek – through her love for the Greek bus driver Prokopis (Alexis Georgoulis). Essentially, the movie serves as a stereotyped touristic commercial, structured as a reverent showcase of some of the most famous Ancient Greek monuments, which include Ancient Olympia, Delphi, and, of course, the Parthenon. This scene is the first stop along the tour, at the Ancient Agora in the centre of Athens. The first monument Georgia and her group encounter there is the temple dedicated to Hephaestus, also known as the Hephaesteion, a Doric temple completed in 415 BC. and located on the north-west side of the Agora at the top of the Agoreos Kolonos Hill. Poor Georgia does her best to get across her enthusiasm and admiration for antiquity, but her rather crass group of foreigners are more attracted to the antics of her shrewd colleague, Nikos, who lures them into shopping and eating, leaving her standing alone 'in the middle of civilization and culture', as she puts it. **◆ Nikos Tsagarakis**

Directed by Donald Petrie
Scene description: The first stop along Georgia's tour, at the Ancient Agora
Timecode for scene: 0:12:52 – 0:16:18

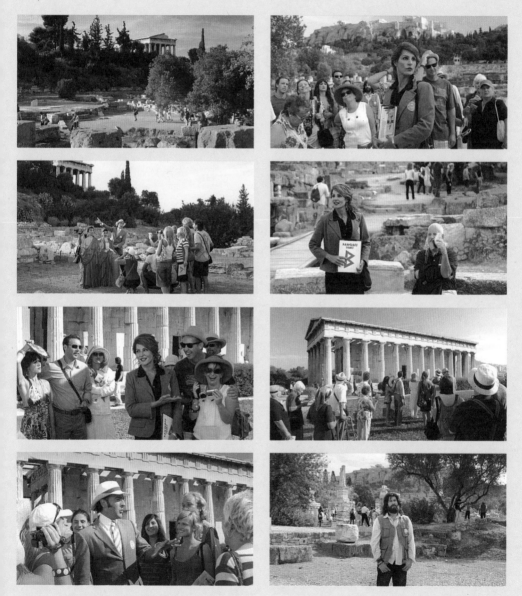

PLATO'S ACADEMY/AKADIMIA PLATONOS (2009)

LOCATION *Intersection of Vassilikon and Emonos Streets, Kolonos*

IN ANTIQUITY, KOLONOS, situated near Plato's Academy, was considered the most prestigious location in Ancient Athens. Today's densely populated working-class district serves as the backdrop to intercultural tensions among the inhabitants of the fast growing Greek capital. The film's dark and, at the same time, ironic and comic narrative unfolds in parallel with the apathetic and frivolous mood that runs through the protagonist's days. Director Filippos Tsitos provides an insightful glance at contemporary Greek 'slackers' that boast the heritage of Plato and Socrates while spending their time sitting around, drinking and nattering outside their corner shops; establishments that sell goods that no one seems interested in buying. They share a non-participatory coexistence and look down on the industrious Chinese immigrants and Albanian workers who are willing to do the jobs the Greeks will not do. The personal stagnation and dissonance of Stavros, the main protagonist, is intensified even further when his mother suddenly starts speaking fluently in Albanian, defying the family history and identity, and even going so far as to recognize her long-lost son. The local municipality's decision to erect a monument to intercultural solidarity in a square Stavros and his friends consider their own awakens them from their lethargy and they attempt to resist the domination of the cultural cityscape through a soccer game. This is the only scene where we actually see the characters take action: destroying the provisional fence used to protect the small construction site, falling about on the ground and even allowing the alleged Albanian brother to play with them. **⇢ *Eirini Sifaki***

Directed by Filippos Tsitos
Scene description: *Stavros and his friends play soccer in the street*
Timecode for scene: 0:34:50 – 0:37:46

A WOMAN'S WAY/STRELLA (2009)

LOCATION *60 Konstantinoupoleos Avenue, Gazi*

A TRAIN CROSSES the frame left to right. Strella (Mina Orfanou) is then revealed standing before the railway tracks. A close-up of her beautiful legs shows her struggling to balance on her high heels as she crosses the tracks to get across to Konstantinoupoleos Avenue to Gazi, Athens's infamous gay neighbourhood. Panos Koutras's film is effectively all about crossing lines – physical, representational, ideological, corporeal. Carrying a rusty chandelier she just picked up from the garbage, the protagonist heads home. As Strella's transsexual body traverses the streets of the city, *Strella*'s transgressive frames transverse the Greek capital both visually and ideologically. From the old chandelier to her very own body, Strella's flair for reconstructing reflects *Strella*'s own restructuring of the familiar familial and national narratives. Much as the film's narrative reverses and regenders the archetypal Oedipal myth having the father forming an intimate relationship with his transsexual son, its spatial explorations reverse the traditional contradistinction between the village and the city. Indeed, the village in *Strella* is no more the refuge of the urban alienated subject but a haunting ideological space, while the city is foregrounded as a productive space of affective resilience, rather than a mere negative place of civic alienation. As Koutras's camera navigates the audience through the city's well-hidden queer interstices, such as the drag show bar Koukles, Athens itself emerges as a queer Utopia; one where the human existence tests its limits, confronts its worst nightmares but, simultaneously, indulges in its most extreme fantasies and dreams of a better collective future.
◄‣ Marios Psarras

Directed by Panos H. Koutras
Scene description: Strella returns home
Timecode for scene: 0:19:19 – 0:20:08

KNIFER/MACHEROVGALTIS (2010)

LOCATION *Argo Theatre, 15 Elefsinion Street, Metaxourgio*

KNIFER presents the decadence of Greek petit bourgeois society and deconstructs the contemporary Greek family, highlighting the power relations that develop within them. Using a realistic *mise-en-scène*, noir aesthetics and stylized black-and-white photography, Economides captures the inner world and the internal violence of his characters in an allegory for Modern Greece. Nikos (Stathis Stamoulakatos), a young man with no dreams or ambition, lives in a gloomy industrial city in the provinces. After the death of his father, he reluctantly accepts his uncle's offer to go to Athens to work and live with him and his wife. There he finds himself in a colourless, run-down suburb on the edge of the city, taking care of his uncle's dogs. Alienated and driven by envy, lust and anger, Nikos embarks on a relationship with his aunt and a power-struggle with his uncle. He will only gain a sense of belonging when he goes downtown, to Metaxourgio, an old working-class area in transition: until recently the home to immigrants and brothels, it is currently being transformed into a modern, trendy district with cultural venues that are displacing its old inhabitants. Once there, he strolls along the metro's airway ducts before he spots a crowd of people waiting outside a theatre. He joins them and, in the only colour scene of the film, we see him sitting among the audience, smiling for the first time. His mind is made up: he too can have a life like other people and be his own boss; all he has to do is kill his uncle. ⇥*Dimitris Kerkinos*

Directed by Yannis Economides
Scene description: Just before he becomes a knifer, Nikos goes to the theatre
Timecode for scene: 1:24:04 – 1:28:47

THE GUIDE/O XENAGOS (2010)

Kypseli Municipal Market, 42 Fokionos Negri Street

A COMEDY SET against the backdrop of a city caught between a glorious past
and an uncertain future, *The Guide* follows Iasonas (Michalis Economou),
a young guide visiting Athens in order to organize a city tour for a group of
architecture students. During the following days, Iasonas not only has to
deal with the group's overwhelming desire to bask in the Mediterranean sun
rather than suffer through his dry lectures on classicism, but he is also forced
to come to terms with his suppressed homosexuality. With its bleak post-war
apartment buildings and the haphazard glass and metal monstrosities built
side-by-side with neoclassical structures and Ancient Greek ruins, modern-
day Athens serves as a perfect analogue of the confused hero's frustrations.
First-time director Zacharias Mavroeidis conjures up the film's most laid-back
view of the city through an energetic montage of the group's leisurely walks
around the neighbourhood of Kypseli (Greek for beehive), an area rarely
depicted on-screen, where empty lots gape next to blind facades and coarse
graffiti decorate old buildings. These locations are hardly tourist attractions,
but they play an important part in recent urban history, such as the building
at 37 Lelas Karayanni Street, which has been occupied by squatters since 1988,
or the historic indoor municipal market, which has served several purposes
throughout the years, from exhibition space and cultural events centre to
Citizens' Advice Bureau. However, it is at these moments, when the students
are wandering around, that they seem to finally adapt to the rhythm of the
city: an unmistakeably messy, yet somehow irresistible, entity, which – much
like Iasonas himself – is struggling to find its identity. **◆Thanassis Patsavos**

Directed by Zacharias Mavroeidis
Scene description: Iasonas takes his group to the neighbourhood of Kypseli
Timecode for scene: 0:45:29 – 0:47:53

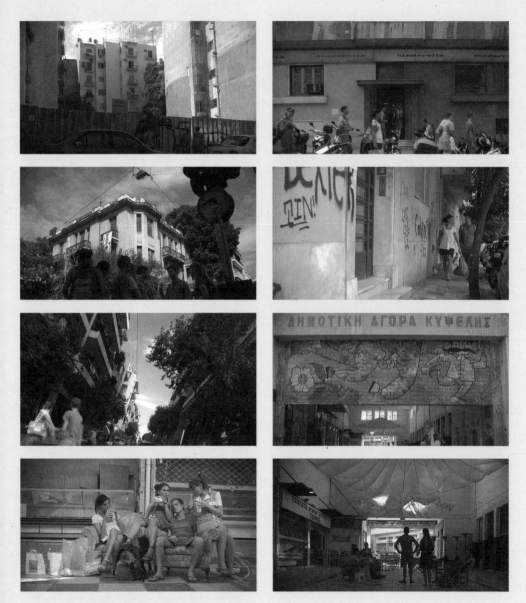

ATHENS IN THE 1960s – GREEK MUSICAL

Text by
LYDIA
PAPADIMITRIOU

DESPITE NOT BEING the most populous genre, musicals were the most popular Greek films of the 1960s, reaching the top of the box office in Greece for seven consecutive years (1963–69). Eschewing any explicit references to sociopolitical tensions, the musical projected an image of optimism fuelled by the rapidly increasing prosperity experienced during that period. The changes in the Athenian cityscape were one of the most obvious markers of this foreign-aid-derived and tourism-triggered affluence, and the musical of the 1960s celebrated them.

Combining comic narratives often shot in the studio with numbers inspired by the Greek music hall (the *epitheorisi*) and American musical films, Greek musicals used location shooting selectively in order to showcase particular settings. The majority of Greek musicals were directed by Yannis Dalianidis and produced by the main Greek studio, Finos Films. Dalianidis's early musicals best exemplify this tendency. A characteristic

is their 'signature' sequence in which the main characters, happily crammed into an open-top car, ride around Athens and its environs, singing about the beauties of the city or the pleasures of its nearby beaches: *Meriki to protimoun kryo/Some Like It Cold* (Yannis Dalianidis, 1962) opens with four siblings and their parents travelling by car to a beach near Athens on a hot Sunday in July. We follow the car initially down Syngrou Avenue and then on along the coastal road that leads to the nearby beaches, listening to the characters singing and exchanging humorous one-liners. We are invited to look at the vehicles – both modern and old – and to experience the road as a path towards freedom and pleasure. In *Kati na kei/ Something Hot* (Yannis Dalianidis, 1964) a similar car trip brings the characters to the capital from the northern city of Thessaloniki, while in *Koritsia gia filima/Girls for Kissing* (Yannis Dalianidis, 1965) the director uses long and overhead shots to celebrate the Athenian cityscape and its monuments during the two main characters' drive from the Port of Piraeus to the city centre: we see the Acropolis, the Zappeion Mansion, the fountains in at Omonia Square, the Hilton Hotel, new underground underpasses and bridges.

Dalianidis's musicals from the mid-1960s introduced a cosmopolitan outlook into the genre. Opening in New York and Paris respectively, *Girls for Kissing* and *Rendez-vous ston aera/Rendez-vous in the Air* (Yannis Dalianidis, 1966) quickly move the action to Greece – initially Athens – and create favourable analogies with the homeland. If New York has skyscrapers, Athens has newly developed squares, hotels and bridges; if Paris has historical buildings, so does Athens with all its ancient sites.

But this cosmopolitan – or, in Dalianidis's words, 'international' – outlook, which sought to

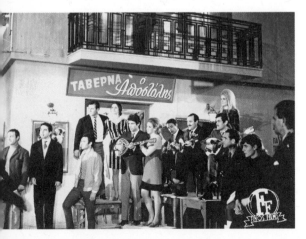

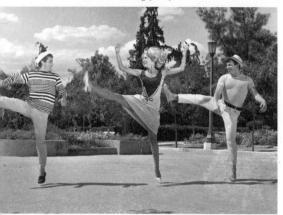

associate Athens with the western metropolises and with the overall project of modernization and westernization, changed direction after 1967, becoming more focused towards the 'national'. Set largely in Piraeus, the Port of Athens, Yorgos Skalenakis's black-and-white *Diplopennies/Dancing the Sirtaki* (1966) placed more emphasis on working-class culture. Its first number depicts the labouring protagonist on a building site, playing the bouzouki and singing, while rhythmically intercut shots of people dancing in the streets – sailors, children, a butcher – are used to celebrate the authenticity of the chosen locations, integrate the musical with scenes of everyday life into the musical and establish what Skalenakis called the 'national' musical.

Dalianidis's ensuing subsequent musicals embrace a similar approach, utilizing more typically Greek music and depicting working-class job-seeking heroes. Tourism becomes increasingly portrayed as an employment opportunity for the aspiring young protagonists. *I thalassies i handres/ The Blue Beads from Greece* (Yannis Dalianidis, 1967) opens with a group of young men selling souvenir dolls to foreign tourists on Filopappos Hill, opposite the Acropolis, in full view of the ancient monument. An American tourist joins them and talks about 'business'. The men 'thank' him with an excessive demonstration of Greek hospitality after following a song-filled drive to Piraeus through

To 1960s musicals, Athens offered a site of rapid transformation and modernization that was ripe for celebration.

the centre of Athens that showcases recognizable sites, as well as old and new buildings. Despite being set almost exclusively in Athens, and especially in its oldest part, Plaka, the rest of the film is predominantly shot in the studio, reducing the use of space to its narrative function.

Skalenakis's *Epihirisis Appolon/Appolo Goes on Holiday* (1968), on the contrary, revels in the use of location, using the narrative premise of a foreign prince enamoured with a Greek tourist guide to offer a cinematic tour of Athenian and other Greek attractions. The film opens with the young heir boarding his helicopter, thus offering narrative motivation for spectacular aerial shots of Athens. The film moves between various locations, from the city centre to the port, from Plaka to Syntagma Square, staging musical numbers everywhere and reinforcing a tourist gaze.

While *Appolo Goes on Holiday* glosses over class differences, Dalianidis's *Mia kyria sta bouzoukia/A Lady at the Bouzouki Club* (1968) places them centre stage and uses location to underscore them. Opening among singing and dancing workers on the docks at the Skaramangas shipyard, the first sequences are set in a working-class neighbourhood west of Athens, probably in Peristeri. The distinctive low-rise architecture and the traditional strict patriarchal mores satirized in the film underline this. The sexually liberated rich woman of the title, in contrast, lives in the expensive neighbourhood of Paleo Psyhiko, and is seen among private yachts at an exclusive part of the marina. Dalianidis's *I Pariziana/The Woman from Paris* (1969) also uses location shots in one of the working-class western neighbourhoods of Athens, thus assigning its central character a specific social identity and emphasizing the aspirational role of her trip to the cosmopolitan and upmarket tourist island of Mykonos.

To 1960s musicals, Athens offered a site of rapid transformation and modernization that was ripe for celebration. The city's ancient monuments were used as emblematic backdrops, alluding to tourist imagery. Skalenakis's penchant for setting musical scenes on location and integrating them with everyday imagery is largely adopted by Dalianidis, and during that decade the genre resorted increasingly more to location shooting in Athens. By the 1970s, the genre had reached its peak and soon declined. The utopian and escapist Athens of the musical soon gave way to the darker and alternative depictions of the city in the New Greek Cinema. ✢

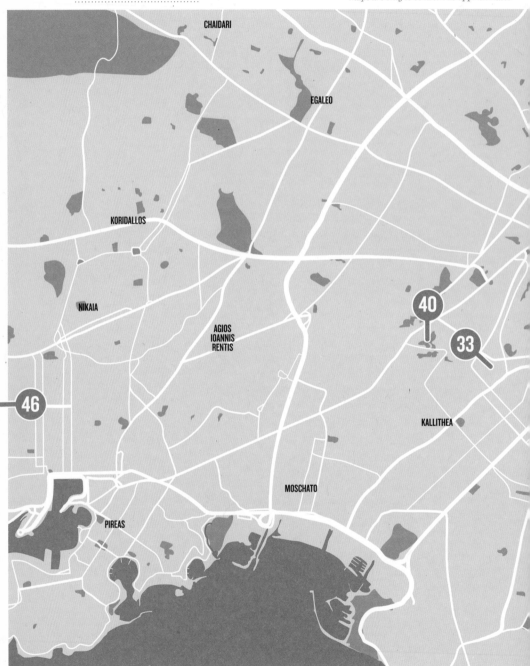

CHAIDARI

EGALEO

KORIDALLOS

NIKAIA

AGIOS
IOANNIS
RENTIS

40

33

46

KALLITHEA

MOSCHATO

PIREAS

ATHENS LOCATIONS
SCENES 40-46

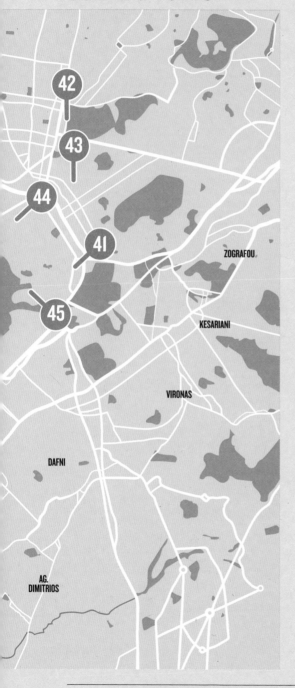

TUNGSTEN (2011)

LOCATION *Attalias Square, housing projects in the working-class district of Tavros*

JUST AS THE METAL TUNGSTEN (wolframium) is conductive to electricity, so are people prone to violence in the Athens of the economic and moral crisis, as depicted in this film by Giorgos Georgopoulos. In the scene chosen, two friends (nobody has names in this film), one tall and blonde (Omiros Poulakis), the other shorter and dark-haired (Promitheas Aliferopoulos), in their mid-twenties, are walking aimlessly in the working-class district of Tavros. Using a fluid camera, with several tracking-shots from behind and intense contrasts in lighting, the director very often depicts the two friends against the light under shaded spaces, in long dark corridors, or in front of glassy surfaces, often making them seem in frames of concrete composition. These dark frames are interchanged with some overlighted (by the strong sun) shots of empty spaces, in which the two friends sometimes seem 'crushed' by the immense buildings behind or in front of them. Although it is evident that the two friends love and support each other, their feeble conversations are a mixture of youthful slang and insults. The impossibility of communication is obvious in the dialogue between one of the characters and his younger sister. The end of this scene leaves the two friends ready to reciprocate the violence which the blonde one (the most mature character of the film) suffered that same morning at the hands of a ticket controller who found him on the bus without a ticket. But the rest of the film holds many surprises. **⇢ Maria Paradeisi**

Directed by Giorgos Georgopoulos
Scene description: Two friends are wandering around the neighbourhood
when they spot the ticket controller going into his building
Timecode for scene: 1:13:50-1:18:07

WASTED YOUTH (2011)

Syntagma Square

OPENING THE 40TH EDITION of the International Film Festival Rotterdam in 2011, *Wasted Youth* was received abroad as an urban road movie about the city of Athens and a society in crisis. Depicting the portraits and the itineraries of youth in the city has become a common narrative choice for young directors who are tackling the existential woes of an alienated, lazy, apolitical, lost generation. Inspired by one of the most shocking events that recent Greek history has to offer (the murder of a 16-year-old by a police officer in December 2008), the directors deliberately avoid factual accuracy and choose the path of moral relativism. Broken into parallel action, the story follows a teenage skater setting off on a normal day of wandering around in the city and skating with friends, and a distressed middle-aged policeman, tense and frustrated with his work and family life in the midst of an economic crisis that terrifies him. The use of teenage amateur skaters for the roles of the protagonists grants the film its sense of immediacy. The raw performances by Haris (Haris Markou) and his friends in Syntagma Square (one of the most symbolic sites of Athens), shot using a handheld camera, vibrate to Larry Gus's hip hop rhythm. Fast travelling, slow motion and accelerations support the attempt to capture the feeling of freedom on the skateboard and the vibrancy of the city, with the view of the Greek Parliament that in real life would be set on fire. This is indeed a period where reality is more spectacular, captivating and dramatic than fiction.
↝Eirini Sifaki

Directed by Argyris Papadimitropoulos and Jan Vogel

Scene description: Haris and his friends are skating in Syntagma Square
Timecode for scene: 0:22:06 – 0:25:33

Images © 2011 Oxymoron Films, Stefi Films

DEAD EUROPE (2012)

LOCATION *Pedion tou Areos*

DEAD EUROPE is a film adaptation of the same-titled novel by Greek Australian writer, Christos Tsiolkas. This unsettling film follows Greek Australian Isaac (Ewen Leslie) as he travels to Greece for the first time in order to scatter his father's ashes. The Athens he encounters is a city enveloped in hostility and populated entirely by immigrants and refugees. It is perhaps this hostility that never materializes in the city centre that makes a brief scene at the Pedion tou Areos, one of the city's largest public parks, so disconcerting. Designed in the 1930s in order to honour the heroes of the Greek Revolution and then renovated in 2011, the Pedion tou Areos has always been conceived as an oasis from the city's exigencies. Idly strolling along the park's trails, the marble statues of Greece's national heroes watching over him, Isaac has a sexual liaison with another passer-by. For a brief moment, Isaac connects with another person in a space situated outside yet also inside the chaos of Athens. This hopeful moment, however, is interrupted when he realizes that, nearby, a group of Greek teenagers are assaulting a young immigrant boy, Josef (Kodi Smit-McPhee). This astounding scene turns the tables on the viewer's expectations. The danger and violence anticipated from the city and from its foreign 'occupiers' manifests itself instead in a national space that is guarded by the heroes of Greece's past. *Dead Europe* intimates that, at a time when immigrants have become scapegoats for Greece's current sociopolitical and economic crisis, we should be concerned by the mobilization of national narratives as the only possible solution to the problems that afflict the Greek and European sphere. ⇢ *Harry Karahalios*

Directed by Tony Krawitz
Scene description: Isaac meets Josef, an immigrant boy
Timecode for scene: 0:16:12 – 0:18:29

BOY EATING THE BIRD'S FOOD/
TO AGORI TROI TO FAGITO TOU POULIOU (2012)

LOCATION *54 Themistokleous Street, Exarhia*

THE BOY (Yannis Papadopoulos) has no name, no friends, no job, no money, no history, no past and no future. He is starving and he devises ways to feed himself without stealing or begging: eating fruit from the trees in backyards, drinking his neighbour's water and sharing bird food with his canary. Trained as an opera singer, the boy is a remnant of a former middle-class generation, highly educated and cultivated but incapable of feeding himself. The city where the boy lives has no landmarks; it is not filmed by establishing shots or panoramic images. Despite the social allusions of his subject, in this no-budget film, Ektoras Lygizos avoids depictions of everyday life, doesn't allow reality to enter his story and builds a capsule around the body of his actor: the tight framing leaves no space for urban scenography and gives the film the form of an allegory for the struggling young artist during the crisis. The experienced city walker will recognize noisy Panepistimiou Street outside the Titania Hotel and the Ideal cinema, as well as a desolate Patission Avenue, lined with boarded-up shops. In this particular scene, the boy is trying to extricate a piece of junk food from the garbage without being noticed. We recognize the building at 54 Themistokleous Street, the main gate to Exarhia Square. An example of modernist architecture dating back to the 1930s, it still displays bullet holes from urban fighting during the civil war. Used in many films as a setting or an interior and owned, until recently, by the independent distribution company Ama Films, this building is an unassuming cinematic space in the district of Exarhia, exemplifying how art, film, economy and politics are always interlaced. ⭢*Anna Poupou*

Directed by Ektoras Lygizos
Scene description: The boy finds his food in the garbage
Timecode for scene: 0:06:02 – 0:07:03

On the side, there is a thing...

Images © 2012 Giorgos Karnavas, Guanaco, Oxymoron Films

LUTON (2013)

Menandrou Street, Psyrri

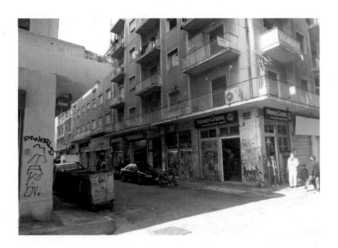

LUTON, the first feature film by Michalis Konstantatos, came out to further enrich the already flourishing trend of contemporary Greek cinema. Following a different path to his contemporaries in terms of cinematic language, Konstantatos made a film about a violence which we don't see, but which we somehow sense is 'out there'. Jimmy (Nicholas Vlachakis), Mary (Eleftheria Komi) and Makis (Christos Sapountzis) are three people leading their everyday life in entirely different ways. They have nothing in common and we mistakenly assume that they probably don't even know each other. Jimmy is a high school student from a wealthy family, about 17 years old. Mary is a trainee lawyer in her thirties. Makis is a 50-year-old family man and owner of a mini-market. In this particular scene, we witness what is, regrettably, a very common occurrence that often takes place in the streets of Athens nowadays, with two policemen stopping an immigrant to ask for his or her residence permit. When we realize that the immigrant is in trouble, our protagonists supposedly come to his rescue, reassuring the police that the man is with them and that everything is fine. Along with Evripidou, Athinas and Sofokleous Streets, Menandrou Street forms a large square, which is one of the most colourful and interesting areas in Athens. It serves as a vital point of reference for the daily life of the city's immigrants, includes a vast bustling market, and is a border with Monastiraki and Psyrri, two neighbourhoods known for their tourist and nightlife activity. It is the typical area of a contemporary metropolis where the old meets the new, the local mingles with the foreign, and the tourist encounters the immigrant. •➤**Konstantinos Aivaliotis**

Directed by Michalis Konstantatos

Scene description: Two policemen stop an immigrant and ask for his residence permit
Timecode for scene: 1:14:40 – 1:16:22

TWO FACES OF JANUARY (2014)

The Parthenon

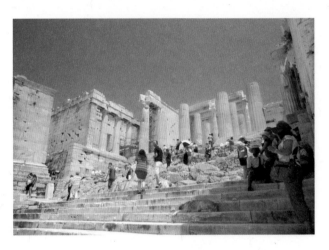

NOT MANY THINGS are the same in Athens today as they were in 1962, but the Acropolis is one of them. Anchored right in the middle of the city, standing above its hustle and bustle, it is and has always been a truly majestic sight. So much so that the hero of Hossein Amini's *Two Faces of January*, Rydal, a sly American living in Greece, feels obliged to warn a group of young American women whom he's guiding around the sights – flirting with them the whole time – that they should get their handkerchiefs ready, as the monument is known to make grown people weep. It is there that Rydal will meet two equally charming but also dodgy American travellers who seem as taken with the ancient pillars and stones as they are with the young man. And it's on the steps on the temple, where Chester and Collete MacFarland stroll, elegantly dressed in clothes the colour of the marbles, that machinations as old as the Acropolis, or even as Man himself, will be put in motion. Three people with obscure motives, enigmatic dispositions and lurking passions will get tangled in a labyrinthine affair spawned in the brilliantly dark corners of Patricia Highsmith's mind. It all will seem thrilling to them and to us. Undoubtedly the marbles have seen it all before.
↝ Yorgos Krassakopoulos

Directed by Hossein Amini
Scene description: Rydal, Chester and Collette at the Acropolis
Timecode for scene: 0:00:48 – 0:03:04

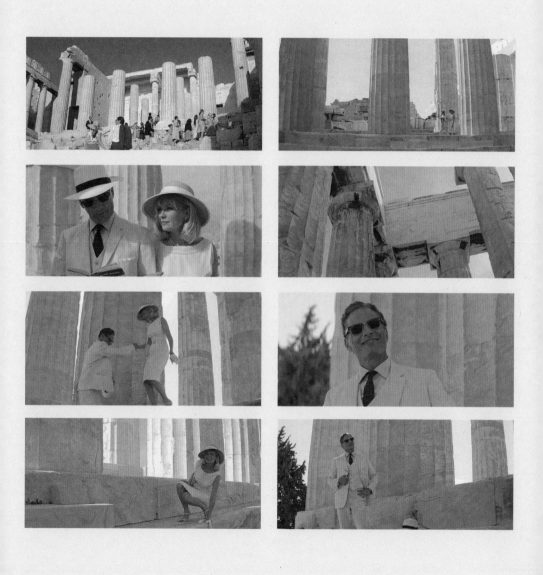

TETARTI 04:45/WEDNESDAY 04:45 (2014)

Fish Market, Keratsini

INNOCENCE AND a perpetual return to the refuge of childhood occupy the heart of Alexis Alexiou's *Wednesday 04:45*, an otherwise dark and violent exercise in postmodern noir taking place in contemporary Athens, a city with a bleak future, very much like that of the central hero Stelios (Stelios Mainas). Alexiou masterfully parallels the transformation of the city with Stelios's spiral descent: a city which was forced to expand, now in decline and destined for chaos; a bankrupt man on the verge of losing control. It is no coincidence that one of the pivotal scenes and the first blood shedding take place in Keratsini, an underprivileged area where the illusion of industrialization goes hand in hand with shades of a lost past. It was here that, in 1929, the extraordinary facilities for the Agios Georgios Mills were built. This was one of the largest flour mills in Greece and one of the first made completely of reinforced concrete, a sign of modernity. However, it is also in this once industrial environment that one of Greece's oldest traditional fish markets is still in operation. In the shadow of this emblematic building lies the derelict fish tavern where Stelios sits waiting to settle his debt with a Romanian mobster. Instead, the mobster's two henchmen show up with a little boy in tow. In the heyday of the stock market, the small tavern attracted the nouveau riche who wanted a glimpse and taste of the unadulterated Greece of yesteryear. Nowadays empty, it looks time-worn just like middle-aged Stelios. As the little boy's ice cream melts on a table, we sense the violent meltdown about to happen. Innocence is lost forever and nothing will be the same from this night on. **•▸ Lefteris Adamidis**

Directed by Alexis Alexiou

Scene description: Stelios meets with two gangsters and a little boy

Timecode for the scene: 1:02:28 – 1:09:47

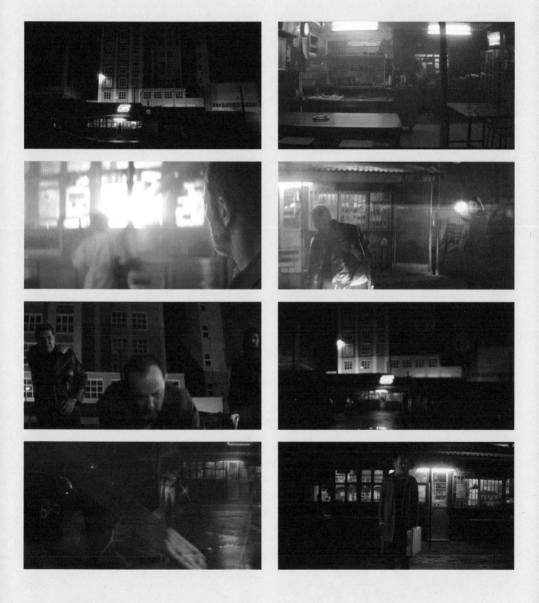

GO FURTHER

Recommended reading, useful websites and film availability

BOOKS

Greek Cinema: Texts, Histories, Identities
edited by Lydia Papadimitriou and Yannis
Tzioumakis
(Intellect, 2012)

A History of Greek Cinema
by Vrasidas Karalis
(Continuum, 2012)

The Greek Film Musical:
A Critical and Cultural History
by Lydia Papadimitriou
(McFarland, 2006)

Popular Cinemas of Europe: Studies of Texts,
Contexts and Frameworks
by Dimitris Eleftheriotis
(Continuum, 2001)

ARTICLES

'A Public View of the City by Greek
Filmmakers of the 1950s'
by Angeliki Milonaki
In *Journal of the Hellenic Diaspora* 37: 1–2 (2011)
pp. 91–105

'Hyperreal Space and Urban Experience in
Contemporary Greek Cinema'
by Eleftheria Thanouli
In *Cinema & Cie 5* (2004)
pp. 100–06

'From Los Angeles to Athens'
by Betty Kaklamanidou
In *Filmed Cities: Eden or Purgatory*
Off Screen 11: 2 (2007)
http://www.offscreen.com/biblio/phile/essays/
filmed_cities

'Archive Trouble'
by Dimitris Papanikolaou
(Cultural Anthropology Online,
26 October 2011)
http://www.culanth.org/fieldsights/247-archive-
trouble

'Global Strategies and Local Practices in Film
Consumption'
by Eirini Sifaki
In *Journal for Cultural Research 7: 3* (2003)
pp. 243–57

ONLINE

Filmicon: Journal of Greek Film Studies
http://filmiconjournal.com/journal
A bilingual (English and Greek), peer-
reviewed, open-access, online journal edited
primarily by independent scholars and
published by 'Eurasia Publications', Athens.

Journal of Greek Media and Culture (JGMC)
http://www.intellectbooks.co.uk/journals/view-
Journal,id=237/view,page=0/
An interdisciplinary peer-reviewed journal
published by Intellect that aims to provide a
platform for debate and exploration of a wide
range of manifestations of media and culture
in and about Greece.

'An Audio-visual Database for Post-War
Architecture and the City in Greece'
http://www.arch.uth.gr/sites/arch-city-avdb/en
Developed by the Laboratory of Environmental
Communication and Audiovisual
Documentation (LECAD) of the Department of
Architecture at the University of Thessaly.

FLIX
http://www.flix.gr
Online magazine with an emphasis on Greek
cinema.

CONTRIBUTORS

Editor and contributing writer biographies

EDITORS

AFRODITI NIKOLAIDOU holds a PhD in Communication, Media and Culture from Panteion University and an MA in Film and Television Studies from the University of Amsterdam. She also holds a Diploma in Film Direction from the Stavrakos Film School. She was coordinator for the Greek Films section of the Thessaloniki International Film Festival from 2003–07. She recently co-edited the volume E. Sifaki, A. Poupou and A. Nikolaidou (eds), *City and Cinema: Theoretical and Methodological Approaches* (Nissos Publications, 2011; in Greek).

ANNA POUPOU has a PhD in Film Studies from Paris University III – Sorbonne Nouvelle, an MA in Theatre Studies from Athens University and a DEA in Film Studies from Paris III. She teaches Film History at the department of Theatre Studies, Athens University and from 2008 to the present she has been teaching as adjunct lecturer at the Universities of Athens, Thessaloniki, Thessaly and Crete. Her most recent publication is E. Sifaki, A. Poupou and A. Nikolaidou (eds) *City and Cinema: Theoretical and Methodological Approaches* (Nissos Publications, 2011).

EIRINI SIFAKI is an independent scholar in communication studies. After a long stay in England and France, where she completed her PhD at the Sorbonne Nouvelle Paris 3, she returned to live in her native Crete. Since 2004, she has been working for different Universities (Aristotle University, the University of Crete, the Hellenic Open University) and has collaborated on a wide range of national and international research projects. Together with Anna Poupou and Afroditi Nikolaidou she co-edited *City and Cinema: Theoretical and Methodological Approaches* (Nissos Publications, 2011; in Greek), while her own research has been published, among others, in *Mésogeios (Méditerranée)*, *Questions de communication*, *Journal for Cultural Research* and *Visual Communication*.

CONTRIBUTORS

LEFTERIS ADAMIDIS worked for six years (2005–10) as the Artistic Director of the Independence Days section of the Thessaloniki International Film Festival and as the editor of several Festival publications, including *Apichatpong Weerasathekul* (TIFF, 2010), *Terence Davies* (Oxy, 2008), *Pinku Eiga* (Egokeros, 2009) and *Philippines Rising* (Egokeros, 2009). He is currently head of acquisitions at One from the Heart Distribution and programme advisor for the Edinburgh Film Festival.

KONSTANTINOS AIVALIOTIS is a graduate of the Department of Social Anthropology at Panteion University and holds two postgraduate degrees – one on the Anthropology of Education (France, University of Rouen) and one on Visual Anthropology (England, Goldsmiths College). He is currently a PhD candidate at the Department of Social Anthropology at Panteion University. He writes for the *cinemag.gr* website. In 2010, he founded the International Ethnographic Film Festival of Athens.

STAVROS ALIFRAGKIS is a graduate of the Department of Architecture, Aristotle University of Thessaloniki (2002) and holds a PhD from the University of Cambridge (2010) on Architecture and Cinema. He has taught courses on the filmic representation of architecture and the city at the Department of Architecture, University of Patras (2009–11) and drawing at the Hellenic Military Academy (2012–13). He has contributed to many conferences and festivals with papers and moving-image linear/interactive projects.

MANOLIS ARKOLAKIS is a Lecturer of European History at the Hellenic Open University. He has also taught History of Cinema at State Training Institutes and was a consultant on issues of pilot Film and TV teaching programmes in primary and high schools.

ERATO BASEA is a Stavros Niarchos postdoctoral fellow at Columbia University, specialized in auteur cinema, film adaptations and transnational aspects of film. She read Classics at the University of Athens and has a doctorate in European Literature and Film from Oxford (2011). Her article 'My Life in Ruins: Hollywood and Holidays in Greece in Times of Crisis' was published in Interactions: Studies in Communication & Culture (3: 2, 2012).

MARIA CHALKOU studied Pedagogy at the Aristotle University of Thessaloniki and Film-making at the Stavrakos Film School. She holds a PhD in Film Theory and History (University of Glasgow), sponsored by the Greek State Scholarships Foundation, and an MA in Film and Art Theory (University of Kent). She is the founding editor of the online academic journal *Filmicon: Journal of Greek Film Studies*.

ELENA CHRISTOPOULOU writes about films, and about people, news and issues relating to films. She also works as the Foreign Press Office coordinator for the Thessaloniki International Film Festival and the Thessaloniki Documentary Festival. She has edited the books *Ulrich Seidl* (TIFF, 2011), *Aki Kaurismäki* (TIFF, 2012) and *Alain Guiraudie* (TIFF, 2013). She holds an MA in Video and a BA in Film Studies, both from Middlesex University, London.

DIMITRIS ELEFTHERIOTIS is Professor of Film Studies at the University of Glasgow and an editor of *Screen* and the *Journal of Geek Media and Culture*. His

➜

forthcoming monograph *Film and Cosmopolitanism* will be published by Edinburgh University Press in 2016.

LEDA GALANOU was born in Athens. She did her postgraduate studies in Film Criticism at City University London. She wrote for *CINEMA* magazine, collaborated with the Athens International Film Festival – Opening Nights, and has worked for film distributors Odeon, Playtime and Audiovisual. She is the film critic for the daily newspaper *I Efimerida ton Syntakton* and co-founded the *Flix.gr* movie website, for which she also writes.

ELIAS FRAGOULIS is a film critic and FIPRESCI (International Federation of Film Critics) member. He has been writing since the early 1990s, especially for magazines. He was the editor-in-chief of the monthly edition of *CINEMA* magazine and, since 1999, he has been presenting and editing *CINEMaD*, the oldest film review programme on Greek television. In 2012 he set up the *freecinema.gr* movie site, which he also runs.

BETTY KAKLAMANIDOU is Visiting Research Fellow at the University of East London, UK and Lecturer in Film History and Theory at the Aristotle University of Thessaloniki, Greece. In 2011 she was awarded a Fulbright scholarship to conduct research in New York.

MYRTO KALOFOLIA is a PhD candidate at the Department of Communication, Media and Culture at Panteion University, Athens. She is a professional translator.

HARRY KARAHALIOS is a Lecturing Fellow in the Spanish Language Programme at Duke University. He teaches Spanish language, literature and culture, as well as contemporary European cinema. He has organized various film festivals and film exhibits, including the annual Chicago Greek Film Festival, which ran from 2003 to 2006.

ATHENA KARTALOU holds a PhD in Communication, Media and Culture (Panteion University, Athens), an MA in Communications (University of Leeds, UK), and a BA in Linguistics (University of Athens). She has extensive experience in events management, especially regarding film festivals, cultural exhibitions and sports events, combined with a teaching background and academic and popularizing writing.

URSULA-HELEN KASSAVETI was born in Athens in 1980. She holds a BA in Greek Literature (School of Philosophy, University of Athens), an MA in Cultural Studies and a PhD in Film Theory and Cultural Studies on the Cultural and Social aspects of the 1980s Greek VHS Production (Faculty of Communication and Media Studies, University of Athens). She works with the Greek Film Archive and European Animation Centre and is a member of the European Narratology Network.

DIMITRIS KERKINOS studied Film at the University of Manitoba in Canada and received a PhD from the Department of Social Anthropology at the University

of the Aegean in Greece. He joined the Thessaloniki IFF in 1999 and since 2002 he has been programming the Balkan Survey section. He has published essays on cinema and anthropology and has edited numerous documentary and fiction film monographs for the Thessaloniki International Film Festival.

YVONNE KOSMA is a cultural sociologist and works as an Adjunct Lecturer. She studied Sociology and Social Theory in Greece and the United Kingdom, and holds a PhD from the University of Athens. She is a member of the ESA Research Network on Sociology of Culture and the Hellenic Political Science Association.

ELEFTHERIA RANIA KOSMIDOU lectures at the Department of Film Studies at the University of Salford (UK). She has also been a Research Associate at University College Dublin since 2013. Currently she is working on her second monograph on European civil war films, as well as on a new research project on contemporary popular European cinema.

ANGELIKI KOUKOUTSAKI-MONNIER is tenured Lecturer (*Maître de Conférences*) in Communication at the University of Haute-Alsace (Mulhouse, France) and a member of the Centre for Research on Mediations (CREM). She holds a PhD in Communication from the University of Paris III-Sorbonne Nouvelle and a BA in Linguistics from the University of Athens.

STELIOS KYMIONIS received a BA in Philosophy and an MA in History and Theory of Cinema from the University of Crete. He is a film historian, curator of audio-visual collections and documentation manager. He has organized a number of conferences on Greek cinema and is a member of Greek and international archival organizations.

MANOLIS KRANAKIS studied Law at the Aristotle University of Thessaloniki. He worked for *CINEMA* magazine from 1997 to 2006 as an editor and from 2008 to 2009 as editor-in-chief. After a long period of freelancing for various magazines, TV shows and distribution companies, he is now one of the proud founders of *Flix.gr*, the first professional Greek website devoted to movies. His life would be entirely different if, along the road, he hadn't met certain people who taught him that cinema has nothing to do with real life.

YORGOS KRASSAKOPOULOS was one of the first editors of *CINEMA* magazine, moving up to become editor-in-chief in the years between 1987 and 2001. He is the film critic for the *Athens Voice* weekly newspaper and one of the founders of the *Flix.gr* film website. He is also one of the programmers for the Thessaloniki International Film Festival and the Thessaloniki Documentary Festival.

IOULIA MERMIGKA is based in Athens and is an independent film scholar and film-maker. She holds BA degrees in Media Arts and History of Art from the University of Plymouth, and an MA and PhD in Cultural Studies and Human Communication from the Media

Department of the University of Athens sponsored by the Greek State Scholarships Foundation. She teaches cinema and cultural studies in lifelong learning programmes.

ANGELIKI MILONAKI earned her PhD in Film Studies at the Aristotle University of Thessaloniki, where she has taught courses on Greek Film History and Film Theory in the Department of Film Studies (2007–11).

DESPINA MOUZAKI is a producer and director and a professor at the Film School of the Aristotle University of Thessaloniki. Her academic records include an MS in Communications and Film from Boston University, Film Finance and Marketing at the Media Business School, Spain and Project Athena at the MIT Media Lab.

LYDIA PAPADIMITRIOU is Senior Lecturer and Programme Leader in Film Studies at Liverpool John Moores University. Her monograph *The Greek Film Musical: A Critical and Cultural History* (McFarland & Company, 2006) has been translated into Greek (Papazisis, 2009). She is the principal editor of the new *Journal of Greek Media and Culture* (Intellect). She is co-editor of the special issue of *Interactions* (3: 2) on *Contemporary Greek Culture* (2012).

DIMITRIS PAPANIKOLAOU is University Lecturer in Modern Greek Studies at the University of Oxford. His research focuses on the ways Modern Greek literature opens a dialogue with other cultural forms (especially Greek popular culture), as well as other literatures and cultures; the other important strand of his research focuses on queer theory and Greek queer cultures.

EFI PAPAZACHARIOU studied Law but turned to journalism, specializing in cultural reportage with a focus on music and cinema. As a journalist, music critic and/or editor, she has travelled around the world, covering events and interviewing artists such as Lou Reed, Sam Shepard, Luc Besson, Atom Egoyan, Peter Gabriel, Nick Cave, Jarvis Cocker, Romain Gavras and Guillermo Navarro.

MARIA PARADEISI is Assistant Professor at the Department of Communication, Media and Culture at Panteion University of Social and Political Sciences, Athens. She teaches History of Cinema and Film Theory (MA in Cultural Studies).

THANASSIS PATSAVOS born in Athens in 1979, he studied Communication and Mass Media at the University of Athens and has worked in almost every aspect of the film-making and media industry, from film extra to press office and copy-editing. He is editor-in-chief of *CINEMA* magazine and curator at the Exile Room screening space.

DESPINA PAVLAKI studied Communication and Mass Media in Athens and Documentary Filmmaking in Barcelona. She has worked as a film programmer and general coordinator at the Athens International Film Festival, the Thessaloniki Documentary Festival, the Nicosia International Documentary Film Festival and the International Countryside Animafest Cyprus.

KATERINA POLYCHRONIADI studied Architecture at the National Technical University of Athens and Visual Anthropology and Urban Sociology at the École des Hautes Études en Sciences Sociales in Paris. Athens is her privileged field of work, along with Paris and Istanbul. She lectures on the History of Architecture, Urban History and Planning in France and is member of the International Network for Urban Research and Action (INURA).

NICK POTAMITIS completed a PhD in 2004 at the University of Birmingham on the impact of the Greek Civil War on the country's popular cinema of the 1950s. He is a published and prize-winning poet and his latest book, *Jubilate Ajax*, is forthcoming with Mountain Press.

MARIOS PSARRAS is a postgraduate researcher at the Department of Film Studies at Queen Mary University of London. He has previously worked as a teacher, theatre director, actor and writer, as well as TV and radio presenter and reporter. He has also made three short films and is currently at the post-production stage of his first feature documentary.

SYLVIE ROLLET is Professor in Film Studies at the University of Poitiers (she previously taught at the Sorbonne Nouvelle University). She has published the book *Voyage à Cythère : la poètique de la mémoire d'Angelopoulos* (L'Harmattan, 2003) and edited a collection of essays on Angelopoulos's work (*Théo Angelopoulos. Au fil du temps*, Presses Sorbonne Nouvelle, 2007).

YANNIS SKOPETEAS is currently Lecturer in Screenwriting and Direction in Digital Audiovisual Arts at the Department of Cultural Technology and Communication, University of the Aegean, Greece. He is also an active practitioner, having written and directed, among others, thirteen hourly documentaries about the history of Greek architecture, as well as a feature-length documentary on the architectural evolution of Athens as depicted in Greek cinema.

NIKOS TSAGARAKIS holds a BA degree from Middlesex University in Film Studies with History, and an MA degree in Film Studies from the University of Crete. He is currently a PhD candidate in Film Studies at the University of Crete and is working on his dissertation on the 'History of the Greek Avant-garde Cinema'.

VASSILIKI TSITSOPOULOU is a comparatist and film scholar with a PhD from the University of Iowa. She has published on Greek cinema and early Greek film culture and has been conducting archival research on early cinematic representations of Ottomans and Levantines (including Greeks).

PHAEDRA VOKALI graduated from the Marketing and Communication Department of the Athens University of Economics and Business in 2005. She is currently working as a producer at Marni Films and has participated in the EAVE Producers Workshop.

FILMOGRAPHY

All films mentioned or featured in this book